Healing Plants
from
Elizabeth Blackwell's
"Curious Herbal"

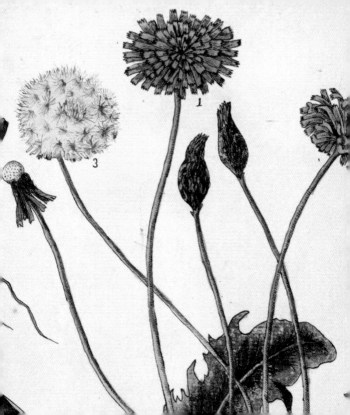

HEALING PLANTS

FROM

Elizabeth Blackwell's
"Curious Herbal"

EDITED BY
MARTA McDOWELL

A Tiny Folio
Abbeville Press
New York London

The information presented in this book does not constitute health or medical advice.

Front cover: Elderberry (*Sambucus nigra*), detail; see page 93.
Back cover: Pot Marigold (*Calendula officinalis*); see page 199.
Frontispiece: Dandelion (*Taraxacum officinale*), detail; see page 83.

ILLUSTRATION CREDITS
Page 6: Trustees of the British Museum, London
The plates in this book are reproduced from *A Curious Herbal* by Elizabeth Blackwell. This includes volume one (London: Printed for Samuel Harding, 1737) and volume two (London: Printed for John Nourse, 1739). These two volumes are housed at the Peter H. Raven Library, Missouri Botanical Garden, St. Louis, and digitized by the Biodiversity Heritage Library. Page 27 is reproduced from the first volume of the herbal (London: Printed for Samuel Harding, 1737) held at the National Library of Medicine, Bethesda, Maryland.

Editor: Lauren Orthey
Proofreader: Stephanie Baker
Designer: Misha Beletsky
Production director: Louise Kurtz

Scientific review of plant species by Tim K. Lowrey

First edition
10 9 8 7 6 5 4 3 2 1

ISBN 978-0-7892-1481-2

Library of Congress Cataloging-in-Publication Data available upon request

For bulk and premium sales and for text adoption procedures, write to Customer Service Manager, Abbeville Press, 655 Third Avenue, New York, NY 10017, or call 1-800-ARTBOOK.

Visit Abbeville Press online at www.abbeville.com.

CONTENTS

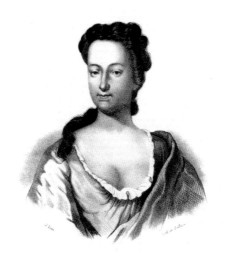

*This is the only surviving portrait of Elizabeth Blackwell,
and is likely an imagined rendering of the artist.*

Jules Lion, printmaker (active 1831–1836). Portrait of Elizabeth Blackwell,
from Alex Delacoux, *Biographie des Sages femmes célébres*, 1834 (detail).
Lithograph, 5 × 4¼ in. (12.5 × 10.8 cm). British Library, London

INTRODUCTION
Elizabeth Blackwell, Healing, & Herbs

WHAT LED Elizabeth Blackwell, an eighteenth-century London woman, to illustrate, write, and publish a compendium of nearly five hundred plants? It was the mid-1730s, and few women had published any type of book. But like the motivation for many artistic endeavors past and present, the answer is simple: Elizabeth Blackwell needed the money.

Until the run-up to Abbeville's 2022 reprint edition of *A Curious Herbal*, little was known about Blackwell save the herbal itself, plus the brazen and ultimately fatal employment record of her husband, Alexander, executed for treason in Sweden in 1747. Available sources were contradictory at best. As the editor, I was at a loss.

A mutual resource, librarian Tony Willis at Oak Spring Garden Foundation, suggested historian Janet Tyson for her expertise. (Thank you, Tony!) As luck would have it, Tyson had just completed her doctoral dissertation on Elizabeth Blackwell and was available to write the biographical essay. During her ongoing research that year, Tyson made one of those discoveries of a lifetime: a unique copy of *A Curious Herbal* in the special collections at Duke University.

Contained in the front matter, along with its preface, was a previously unknown autobiographical sketch by Blackwell.

Here are the facts: Elizabeth Blackwell was born on April 23, 1699, to Alice and Leonard Simpson in Poultry, a street in the City of London. Her father was an artist. He taught her to draw. Though he died young, from him she inherited her love of plants, especially the wild plants that still grew in profusion not far from their home. As she grew into adulthood, she formed an ambitious plan, "the Prosecution of which would have been business for my whole Life," she wrote. She would create an illustrated guide for plant identification. Alas, love and marriage got in the way.

On the first day of October 1733, thirty-four-year-old Elizabeth Simpson married Alexander Blackwell, a promising young Scotsman who had come to London and taken up the printers' trade. Details of their meeting and courtship are unknown. He was well-educated and no doubt charismatic, as over the course of his working life he talked himself into many positions for which his qualifications were questionable. By their first wedding anniversary, Alexander was bankrupt. Elizabeth realized her circumstances were "so far reduced," she wrote, "that I found it necessary to consider what I could do towards supporting my family."

At the time, her family likely included her widowed mother and her two sons. Though their birth dates are unknown, William died in 1736 and Blanch Christian in 1738. Elizabeth

Blackwell returned to her original idea from before she was married, of creating a plant-identification manual. Whether through advice or luck, her subject morphed into a reference book of medicinal plants. For this, there was a ready-made market: apothecaries and apothecaries-in-training.

For her project to succeed, Blackwell needed help. Through various connections, facilitated by letters of introduction and, one presumes, her own assertiveness, she gained the patronage of men in the Royal Society of Physicians and those responsible for a peculiar garden in the village of Chelsea, a still rural area of market gardens and manor houses west of the city. This was the Apothecaries' Garden, now called the Chelsea Physic Garden, founded in 1673.

The four-acre garden was operated by the Worshipful Society of Apothecaries, the regulatory body for those engaged in preparing and purveying medicinal treatments. Incorporated as a London livery company by royal charter in 1617, the society has occupied its Hall on Black Friars Lane since the 1630s. To join the society, one needed instruction and to serve an apprenticeship. The garden's primary purpose was to grow and display plants used in the treatment of human ailments.

Medicine chests were, in the eighteenth century and prior, elaborate affairs: hinged wooden cabinets with bottles, drawers, and sometimes surgical instruments. They were filled at apothecary shops with many products that had started out as plants. The Apothecaries' Garden was a living classroom of

applied botany, a teaching garden. Which plants and which plant parts—root, stem, leaf, flower, or seed—were most effective? How should they be prepared? Which could be poisonous?

Using plants to treat ailments was nothing new. Sumerians recorded plant treatments in cuneiform on clay tablets. Healers across the globe in the ancient world—China, India, Egypt, Greece, Rome—compiled herbals with descriptions of plants and their healing properties. Dioscorides, a Greek in the army of Rome, set a standard in the first century with his five-volume treatise, *De materia medica*. English language herbals were commonplace by Elizabeth Blackwell's day. The difference would be in the illustrations. Rather than using stiff woodcuts like her predecessors, Blackwell decided to paint plants from live specimens sourced primarily from the grounds and glasshouses of the Apothecaries' Garden.

While Blackwell was working on *A Curious Herbal*, powerhouse head gardener Philip Miller was building the garden into one of the foremost plant collections in the world. Regular infusions of colonial species, along with indigenous plant knowledge, came from around the expanding empire: gamboge from Asia, gum arabic from Egypt, oil palm from West Africa, and sassafras and lignum vitae from North and South America respectively. Blackwell was fortunate in her timing, positioned to document the Garden's "curious" plants, a global floral pharmacopeia. She took lodgings across from

the garden at Number 4 Swan Walk, the short, quaint lane between the river and what was then Paradise Row, since renamed Royal Hospital Road.

Blackwell's herculean effort took over three years to complete. She set a daunting pace: one set per week, consisting of a page of description and four accompanying illustrations, over 125 weeks. The cost to subscribers was one shilling per set, or two shillings to have the plates colored by hand. Blackwell made the drawings, prepared the copperplates, and wrote the descriptive text, which was then engraved by a specialist in calligraphy. For the text, she had a head start. Author-apothecary Joseph Miller had given her permission to use descriptions from his 1722 book, *Botanicum officinale*. She did not copy verbatim, but edited and summarized Miller's often rambling prose into concise statements.

A Curious Herbal was not an apothecary's recipe book. Instead, Blackwell created a pharmacological ingredient book in pictures and text. There is tradition packed into its pages. We learn dandelion (*Taraxacum officinale*, p. 82) was called piss-a-bed, and drinking too much coffee (*Coffea arabica*, p. 66) already had the reputation of "bring[ing] on them Nervous Distempers." Alongside many species native to the British Isles depicted by Blackwell, one finds New World arrivals such as chocolate (*Theobroma cacao*, p. 62).

If you want to find the healing plants featured in these pages, just walk into any natural foods market, pharmacy,

or grocery store and head for the vitamins and supplements aisle. Now available over the counter, manufacture of alternative health products is no longer the purview of apothecaries like Shakespeare's unfortunate character in *Romeo and Juliet*. Nor does it fall solely to traditional healers of indigenous peoples and "cullers of simples," who have tended rural populations with plant-based treatments for centuries. It is big business. In 2023, Bloomberg estimated the global market for these "nutraceuticals" will reach almost $600 billion by 2030.* While some of these holistic products have mineral, marine, and dairy sources, a significant portion started out as plants, many of them known by Elizabeth Blackwell.

Some of Blackwell's plants, like lavender, may be growing in your garden. Your local garden center will have others in pots, ready for sale. Jars in your pantry cupboard are likely filled with several, including thyme and parsley. You may season your food with black pepper or kick it up a notch with hot pepper. A handful, including sloe and wormwood, may be hiding in liquid form in your liquor cabinet. You may consider a few of them weeds, depending on your locale and growing conditions. But for Elizabeth Blackwell, they were all plants worth knowing, and worthy of curiosity for their healing natures.

*"Nutraceuticals Market to Reach $599.71 Billion by 2030: Grand View Research, Inc.," Bloomberg, April 19, 2023, https://www.bloomberg.com/ press-releases/2023-04-19/nutraceuticals-market-to-reach-599-71-billion-by- 2030-grand-view-research-inc.

THE PLANTS

NOTE: In the following pages, the plants are arranged alphabetically. Details of Blackwell's plates are accompanied by excerpts from the plant descriptions in the first edition of *A Curious Herbal*, maintaining Blackwell's spelling and punctuation. The contemporary common and scientific names for the plants are listed first, with Blackwell's names (where different) in brackets.

Agrimony · *Agrimonia eupatoria*

[*Agrimonia*]

This is the Eupatorium of Dioscorides, Galen, & the ancient Greeks; it grows about two Foot high, having several winged hairy Leaves of a pale green Colour, and yellow Flowers.

It grows in Hedges, and the Borders of Fields, and flowers in June and July.

Agrimony is esteemed cleansing and purifying for the Blood, strengthening the Liver, and good in all Diseases arising from the Weakness thereof, as the Dropsy, Jaundice &c. Matthiolus recommends it with white Wine as an excellent cure for the Strangury and bloody Water. Riverius extols the Powder of the dried Leaves for the Incontinence of Urine. It is likewise a vulnerary Plant, & put in Wound-Drinks; & outwardly used in Baths & Fomentations.

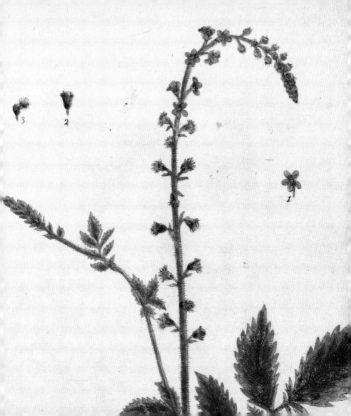

Aloe Vera · *Aloe vera*

[The Common Aloes, *Aloe vulgaris*]

The Stalks grow about two or three Foot high, the Leaves are a whitish Green, and the Flowers a pale yellow.

It grows in Spain, Italy and the West Indies, flowring in the Spring.

The Aloes Hepatica of the Shops or the Barbadoes Aloes is made from this Plant. Aloes is a purging Medicine much in Use, and very beneficial to cold moist Constitutions, but is seldom given by it self unless it be to Children for the Worms. It is a main Ingredient in most of the Officinal Pills, as also in the Species Hiera Picra.

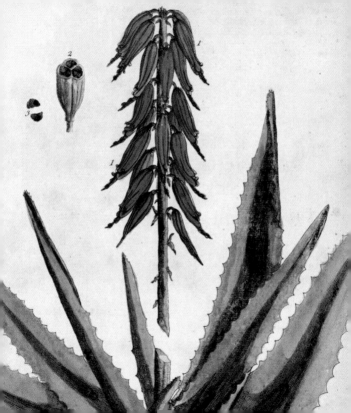

Annual Mercury · *Mercurialis annua*

[French Mercury, *Mercurialis mas* & *foemina*]

It grows about a Foot high, the Leaves are a grass Green, & the Flowers yellowish.

It grows frequently in Gardens, waste Places, and Rubbish, flowring for several Months in the Year.

The Leaves and Stalks are accounted apperative and mollifying, a Decoction of them purges choleric and serous Humours, used in Glisters. Matthiolus commends a Decoction of the Seed with Wormwood for the yellow Jaundice. The Juice is good to take away Warts.

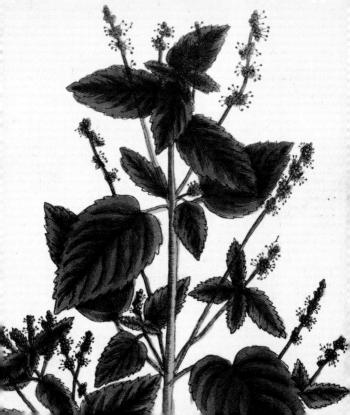

Artichoke · *Cynara cardunculus*

[*Cinara vel Scolymus*]

The Stalks grow about three Foot high, the Leaves are a light Green & the Flowers blue.

It is planted here in Gardens and Flowers in June and July.

Artichokes are esteem'd a pleasant wholesome, and very nourishing Food. The Roots are accounted apperative, cleansing and diuretic good to help the Jaundice and provoke Urine.

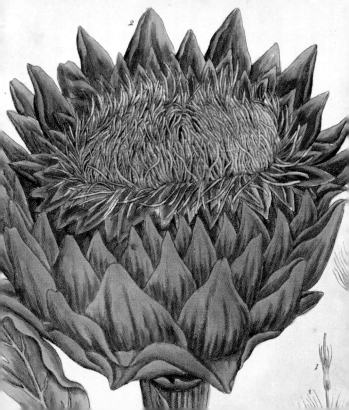

Asparagus · *Asparagus officinalis*

[Sparagus, *Asparagus*]

The Stalks grow about four Foot high; the Leaves are a deep grass Green, and the Flowers greenish, which are succeeded by red Berries.

It is planted in Gardens, and flowers in July.

The Root is one of the five opening Roots, & is esteem'd good for all Obstructions of the Reins & Bladder; as also the Dropsy and Jaundice. The young Shoots, which we call Sparagus, are pleasant & Wholsome Food, being of a cleansing Nature, and light Disgestion, provoking Urine, to which they give a foetid Smell.

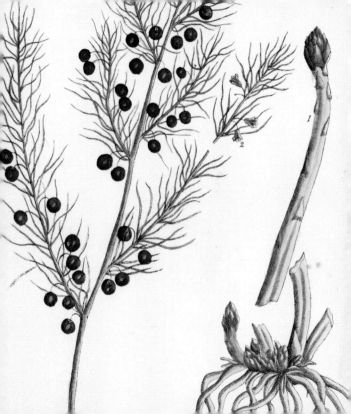

1

2

Beet · *Beta vulgaris*

[Red Beet, *Beta rubra*, or *nigra*]

The Stalks grow about two Foot high, the Leaves are a dark Green, tinctured with Purple, and the Flowers small and Staminous.

It is planted in Gardens and flowers in April and May.

Beets are esteem'd good to loosen the Belly, and temperate hot choleric Humors. The Juice of the Roots is sometimes used as an Errhine being snuffed up the Nose to clear the Head of Flegm and mucous Humors, and by that means to help old Head-Achs.

Betony · *Betonica officinalis*

[*Betonica*, & *Betonica silvestris* or *vulgaris*]

It grows to be eighteen Inches high, the Leaves are a deep grass Green, and the Flowers a red Purple.

Betony grows in Woods & Thickets & by Hedge-sides, & flowers in May and June.

It is accounted a good cephalic, hepatick & vulnerary Plant. The Ancients had it so much in esteem that Antonius Musa, Physician to Augustus Caesar, wrote a whole Treatise on it. The Leaves dried & mix'd with Tobacco are frequently smoaked for the Head-Ach, Vertigo, & sore Eyes. Mixd with Wood-Sage & Ground-Pine, it makes a good diet Drink for the Gout & Rheumatism. The fresh leaves bruised are good for green Wounds & to draw out Splinters. The officinal preparations are the conserve of the Flowers, and the Emplastrum de Betonica.

Birch · *Betula pendula*

[*Betula*]

This grows to be a tall Tree, the Leaves are a bright grass Green, and the Catkins brownish.

It grows in Woods, and the Catkins come out in April.

The Liquor that comes from this Tree, bored in the Spring, is accounted good for the Stone, Gravel, Strangury & bloody Urine. The Leaves are esteem'd good for the Dropsy, & Itch, used both inwardly & outwardly. The Wood next to Juniper, is prefer'd to burn in times of Pestilence & contagious Distempers.

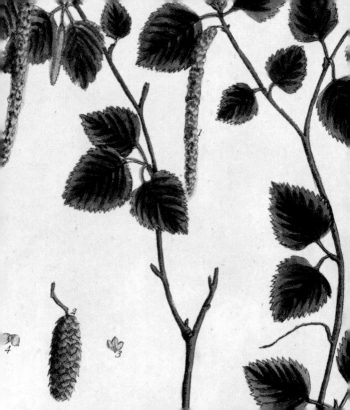

Bishop's-flower · *Ammi majus*

[Bishop's Weed, *Ammi vulgare*]

This Plant grows about three Foot high, the Leaves are a bright grass Green, and the Flowers white.

It is rarely found wild in England; although Parkinson says it grew wild at Greenhith in Kent; it flowers in June.

The Seed is one of the four lesser hot Seeds, used in the Shops; and is accounted drying & warming, good to expell Wind from the Stomach & Guts, and prevent the Collick. It is also diuretic, and helps to provoke Urine and the Courses.

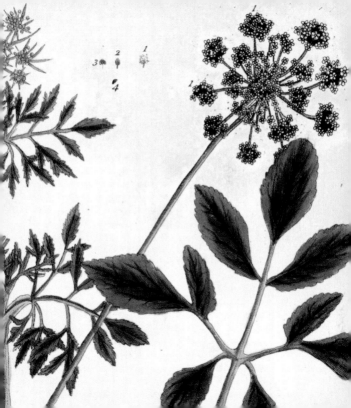

Bistort · *Bistorta officinalis*

[Bistort, or Snakeweed, *Bistorta*]

The Stalks grow a Foot and an half high, the Leaves are a dark grass Green, on the Face, and a willow Green on the Back.

It grows in moist Meadows, particularly Battersea, and flowers in May.

The Roots are esteem'd drying and binding, and useful in all Fluxes and Haemorrhagies, the Incontinence of Urine and making of bloody Water; and are serviceable in pestilential Fevers.

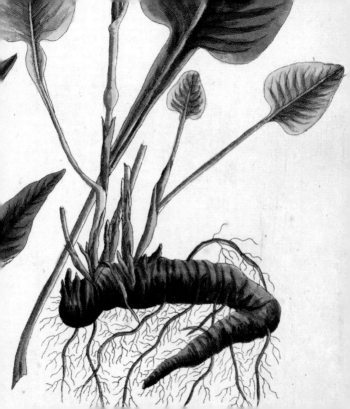

Black Horehound · *Ballota nigra*

[Black or Stinking Horehound,
Marrubium nigrum. Ballote]

The Stalks grow to be two Foot high, the Leaves are a dark Green, and the Flowers a blue Purple.

It grows by High Ways and Hedges, flowring for several Months in the Summer.

Dioscorides says the Leaves beaten with Salt, and applyed to the Wound, cures the Bite of a Mad Dog; and the Juice mixt with Honey is good to cleanse foul Ulcers. Docter Bowle commends it as a singular Remedy against Hysteric & Hypochondriac Affections.

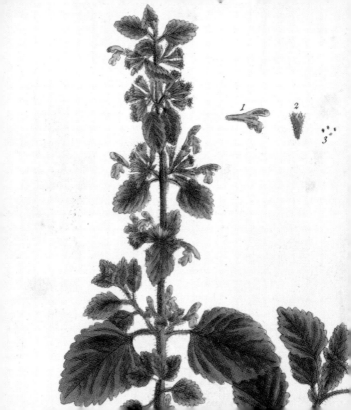

Black Mulberry · *Morus nigra*

[The Mulberry Tree, *Morus. —nigra vulgaris*]

This grows to be a tall Tree, the Leaves are a dark Green, the Flowers yellowish, and the Berries when ripe a dark Purple.

It grows in Gardens, and the Fruit is ripe in August and September.

The Bark of the Root is thought to warm and dry, opening obstructions of the Liver and Spleen, and helping the Jaundice. The unripe Fruit is binding and drying, good in all kinds of Fluxes, and Inflammations of the Mouth and Throat. The ripe Fruit is cooling, good to allay the Heat of Burning Fevers, and create an Appetite.

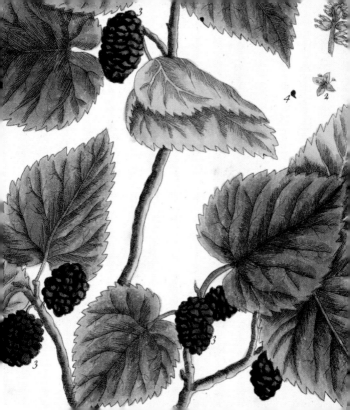

Black Opium Poppy
Papaver somniferum
[Black Poppy, *Papaver nigrum*]

The Stalk grows about three Foot high, the Leaves are a willow Green, and the Flowers a pale Purple with a black Bottom.

It is sown yearly in Gardens, and flowers in July.

The Heads were formerly used in the Sirupus e Meconio, but are left out in the last Edition of the Dispensatory. The Leaves are used in Cooling Ointments, being accounted good for Burns, Inflammations, and hot Swellings; and are put in the Unguentum Populeon.

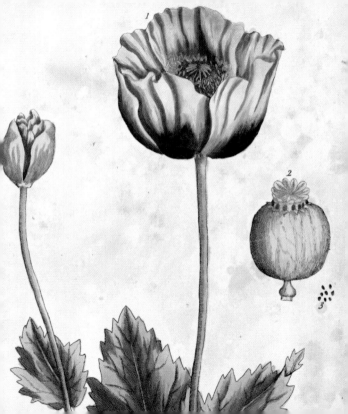

Black Pepper · *Piper nigrum*

This Plant grows like our large white Bindweed; the Leaves are a bright grass Green, and the Fruit a dark Brown.

It grows in the East Indies.

Pepper is heating and drying, good to expell Wind, & ease the Collic; it strengthens the Nerves, Head, and Sight. Pepper shou'd never be Powdered fine, but grossly broken, when it is eaten with Food or used to Season it.

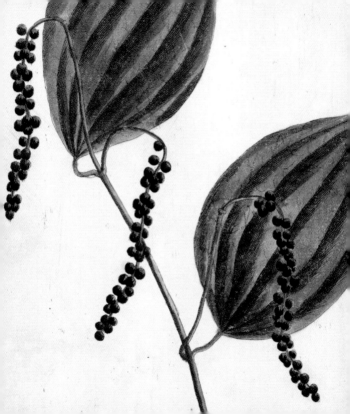

Black Tea · *Camellia sinensis*

[Bohea or Peco Tea, *Thea frutex, Bontii, Chaa*]

This Shrub grows much of a height as the other, and is thought the same by many; and that the only Difference is in the Drying of the Leaves or the Time of gathering them; whereas by what Kempfer says, the Soyl and the Climate make a considerable Difference; his Words are Folium ratione folinatalis, fitus, aetatis haud parum in substantia magnitudine et figura.

It grows in Japan and flowers in Summer. This Specimen was taken from Kempfer, who took it on the Spot.

This Tea is esteem'd balsamic and analeptic; and good for Consumptions; but must be used moderately.

Borage · *Borago officinalis*

[Borrage, *Borrago*, or *Buglossum*]

It grows to be 18 Inches high, the Leaves are a grass Green, and the Flowers Purple.

It grows frequently as a Weed in Gardens; and is often found wild near Houses and upon Walls; and flowers in June.

The Leaves are esteemed cordial, comforting the Heart, preventing Faintness & Melancholy. The Tops are much used in Wine & Cool-Tankards. They are accounted Alexipharmic, and good in malignant Fevers. The Flowers are one of the four Cordial Flowers. The officinal Preparation is the Conserve of the Flowers. Matthiolus recommends the whole Plant distilled, as good for the Inflammations of the Eyes, whether inwardly or outwardly applied.

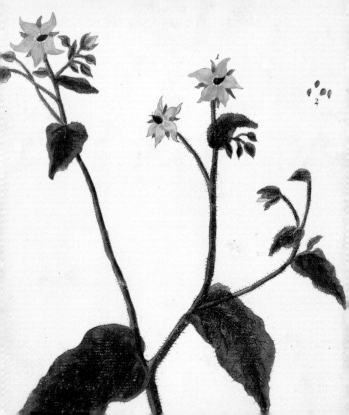

Broad Bean · *Vicia faba*

[The Garden Bean, *Faba major*, or *major hortensis*]

The Garden Bean grows to be three or four Foot high; the Leaves are a pale Green, and the Flowers white, with two black Spots in them.

It is sown in Gardens, and flowers in May, and the Beans are ripe in June or July.

The Water distilled from the Flowers is used by many as a Cosmetic; & that from the Pods is accounted good for the Wind & Gripes in Children. Dioscorides says, the Meal made into a Cataplasm removes the Swellings in Women's Breasts which are occasioned by the Milk; he also recommends it mixt with Roses, Time, & the white of an Egg, as good for purging all watery Rheums from the Eyes; & mixed with Wine as good for the Web & blood-shot of the Eyes. The Meal given inwardly is esteemed good for a bloody-flux. The officinal Preparations are, the Aqua Florum et Siliquarum Fabarum.

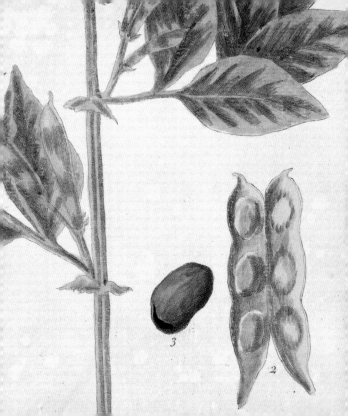

2

3

Broadleaf Plantain · *Plantago major*

[Broad-leaved Plantain, *Plantago latifolia*, or *Septinervia*]

The Stalks of this Plantain grow to be eight Inches high; the Flowers are a whitish Colour.

It grows by Way-sides and Meadows, and flowers in May.

Plantain is cold, dry, and binding; usefull in all kinds of Fluxes and Haemorrhages, as spiting & vomiting of Blood, bleeding at the Nose, the Excess of the Catamenia or Lochia. It is likewise esteemed good for the involuntary making of Urine, its Heat and Sharpness, & the Gonorrhea; it helps to stop the bleeding of Wounds & consolidate their Lips. The officinal Preparation is the Simple distilled Water.

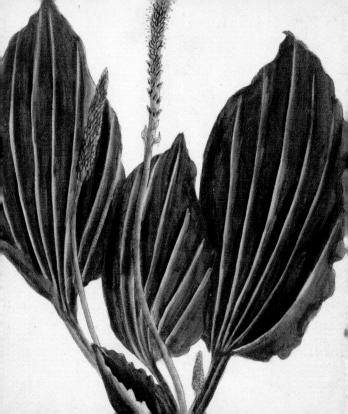

Cardamom · *Elettaria cardamomum*

[The true Amomum, *Amomum verum*]

This Specimen is taken from Mr. Joseph Millar's the Apothecary.

It grows in Bunches of roundish triangular Capsulae, containing black corner'd rough Seed.

This Amomum is warming and comforting, and is good for the Collic, and cold Disorders of the Stomach and Bowels. It also promotes Urine and the Catamenia.

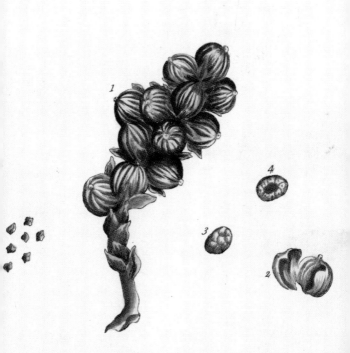

Carnation · *Dianthus caryophyllus*

[Clove July-Flowers, *Caryophyllus ruber*]

The Stalks and Leaves are a light willow Green and the Flowers a fine Red.

They are cultivated in Gardens, and flower in July.

The Flowers are cordial, cephalic, and of use in all Diseases of the Head and Nerves. They are used in Fevers and other malignant Distempers, and in Faintings and Palpitations of the Heart. Officinal Preparations are, A Syrup and a Conserve of the Flowers.

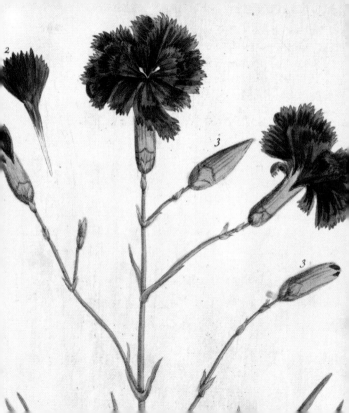

Carob · *Ceratonia siliqua*

[*Carobe* or *Siliqua*]

This Tree grows to a considerable Bigness in its native Climate, the Leaves are a bright grass Green, the Flowers red, the Pods a brownish red, and the Fruit a deep red.

It grows in Syria & Creet, & flowers in the Spring, the Fruit being ripe in Autumn.

Matthiolus recommends the Fruit as good for the Stomach, and Gripping of the Guts, & to provoke Urine. The Decoction of the Beans is accounted by him a great Cure for an inveterate Cough, and the Tissick.

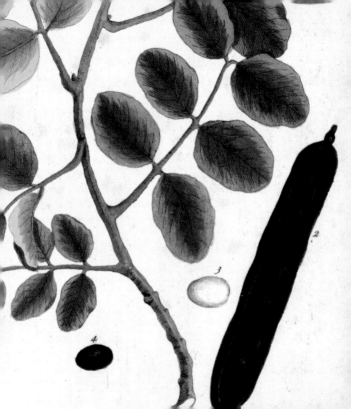

Castor Bean · *Ricinus communis*

[The greater Spurge or Palma Christi,
Cataputia major & *Ricinus*]

The Plant grows to be Six or Seven Foot high, the Leaves are a fine grass Green; the Flowers are small and staminous of a yellow Colour.

It is planted in Gardens, and flowers late in the Summer.

The Kernels are used by some to purge watery Humors; but they must be used with great Caution. The Oil express'd from the Seeds is good to destroy Lice in Children's Heads.

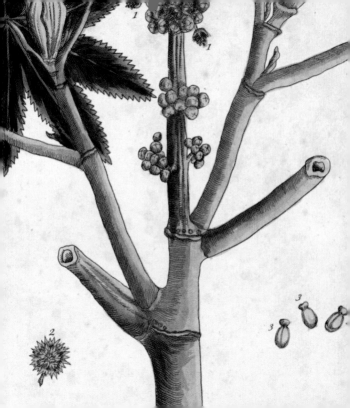

Chamomile · *Matricaria chamomilla*

[Camomile, *Chamaemelum*]

It grows about eight Inches long; the Leaves are a grass Green, and the Flowers white set round a yellow Thrum.

It grows upon Heaths and Commons, flowring in June and July.

It is esteem'd good for the Stomach, Collic, Jaundice, Stone, stoppage of Urine, and Quartan Agues. Outwardly it is used in Glysters, Baths, & Semicupia, for the Stone and stoppage of Urine, as also in Fomentations for Inflammations and Tumors. When applyed hot to the Sides it helps the Pains thereof. The Officinal Preparations are, the Simple Water, the Aqua Chamaemeli composita, the distill'd Oil, and the Oil by Infusion or Decoction.

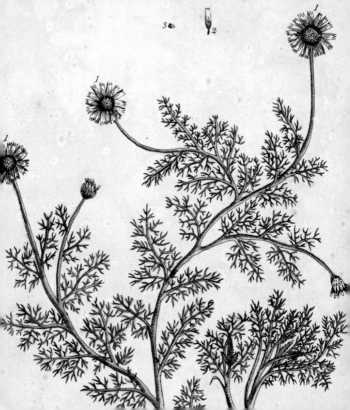

Chaste Tree · *Vitex agnus-castus*

[Agnus castus, or The Chaste Tree,
Vitex, or *Agnus castus*]

This Tree grows about the Bigness of a small Cherry Tree; the Leaves are a dark Green above, and whitish underneath; the Flowers are a whitish Purple, & the Seed a blackish Grey.

It is a Native of Italy, & is planted here in Gardens, flowring the latter End of Summer.

The Leaves Flowers & Seed are esteemed warming and drying; helps the Hardness of the Liver & Spleen, expells Wind & brings down the Catamenia. Formerly the Seed was much used to allay venereal Heats, & preserve Chastity, but this Age has left that Medicine out of their Dispensatory as useless.

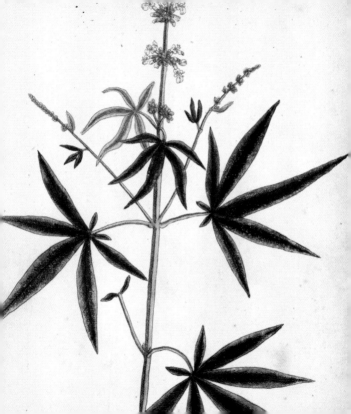

Chocolate · *Theobroma cacao*

[The Coco-Nut Tree, *Cacao*, & *Cacavate*]

This Tree grows to be pretty big in its native Climates, the Leaves are a deep Green & the Flowers yellow. This Specimen is taken from Mr. Joseph Millar's Collection.

It grows in Jamaica and Martinico; but the Best grow in the Caraccos, in New Spain.

The Kernels of the Nuts is what we make the Chocolate of, which is now so much used for Food; being accounted nourishing, restorative, fatning & provocative.

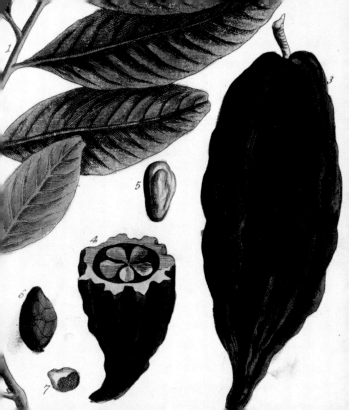

Clove · *Syzygium aromaticum*

[*Caryophyllus aromaticus*]

The Trunk of this Tree grows about the Bigness of a Man's Waist, the Leaves resemble those of the Bay, in shape size and Colour; the Flower is red, and the Seed a reddish Brown.

It grows in the Molucca Islands, in the East Indies; and this Specimen was taken from a Branch of the Tree at Sr. Hans Sloan's.

Cloves are esteem'd heating, drying, cordial, cephalic and Stomatic; being good to stop Vomiting, strengthen a weak Stomach, expel Wind, prevent Fainting and malignant Distempers. The Distill'd Oyl is said to cure the Tooth-Ach, a Bit of Lint being dipp'd in it, and put into the Hollow Tooth.

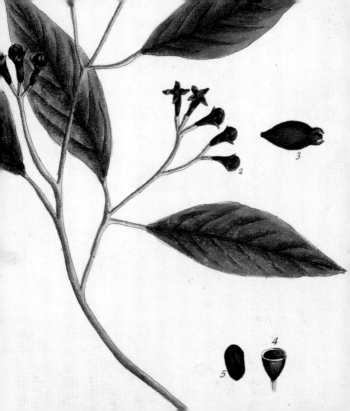

Coffee · *Coffea arabica*

[*Coffee*]

This is a low Shrubby Tree or Bush, with Leaves like those of the Laurel, and Flowers like the Jasmine.

It grows in Arabia Felix; and flowers here in April and May.

The Coffee that is commonly drank, is made of the Berries of this Tree roasted; and is accounted good for those who are of a cold flegmatic Constitution. But for Persons of a thin hot and dry Temperament, the drinking it too much may bring on them Nervous Distempers.

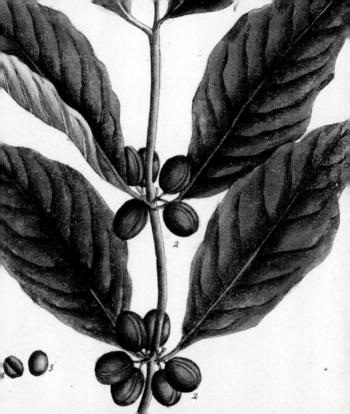

Comfrey · *Symphytum officinale*

[*Symphytum* & *Consolida major*]

The Stalks grow 3 Foot high, the Leaves are a dull grass Green, & the Flowers white.

It grows on Banks by River Sides & Watery Places, flowring in May & June.

The Root Leaves & Flowers are used, being accounted vulnerary, whence it takes the Name of Consolida. It is esteem'd good for inward Bruises, spitting of Blood and sharp corroding Humours that cause Erosions in the Bowels. Some commend the Roots beat to a Cataplasm as good for the Gout. The Officinal Preparation is the Syrup, de Symphyto.

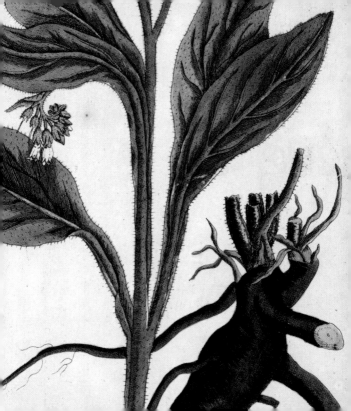

Coriander · *Coriandrum sativum*

[*Coriandrum*]

It grows to be two or three Foot high, the Leaves are a bright Green, and the Flowers white.

It grows wild in some Places, but is commonly sown for the Benefit of the Seed, flowring in June.

The Seed is esteem'd to strengthen the Stomach & expell Wind & is frequently used to correct strong purging Medicines. Some account it good for the Kings Evil.

Costmary · *Tanacetum balsamita*

[Costmary or Alecoast, *Balsamita mas.*
or *Costus hortorum*]

The Stalks grow to be more than a foot high, the Leaves are a yellow Green, and the Flowers yellow.

It is planted in Gardens and Flowers in July.

The Leaves are accounted good to strengthen the Stomach, & ease the Head-Ach arising from the Disorders thereof—It expells Wind and prevents sour Belchings. Outwardly it is used in Fomentations to comfort and strengthen the Limbs.

Cowslip · *Primula veris*

[The Cowslip or Paigle, *Paralysis*]

The Stalks grow about six Inches high, the Leaves are a grass Green above and whitish underneath, and the Flowers yellow.

It grows in moist Meadows and Marshes, flowring in April.

The Flowers are accounted cordial, and beneficial to the nervous Sistem, good against the Epilepsy, Palsy, Apoplexy & Pains in the Head. Some say they are anodyne & good to procure sleep for which Purpose they make Tea of them. The Leaves are used in warming, strengthening Ointments, particularly the Unguent Nervinum. Officinal Preparations are, The Simple Water, The Syrup, and the Conserve.

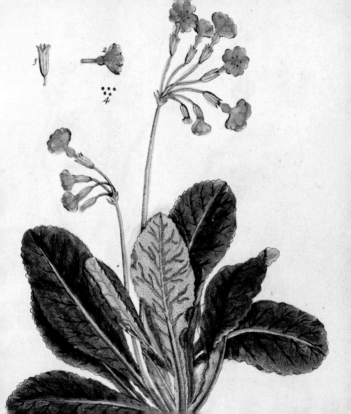

Cuckoopint · *Arum maculatum*

[Wake Robin or Cuckow-pint, *Arum*]

The Stalks grow more than a Foot & an half high, the Leaves are a deep Green, the Flowers purple and the Fruit a yellowish Red.

It grows in Hedges and dry Ditches, and flowers in May.

The Roots dryed & powdered are accounted good for a Cachexy, the Scurvy & Asthma; and the Quantity of a Drachm of the Roots of the Spotted sort dryed is commended as an excellent Antipestilential & the Leaves beat to a Cataplasm is good for Plague Sores. Matthiolus says a Poultice of the Roots beat to mash & mix'd with Cow Dung, eases the Pains of the Gout.

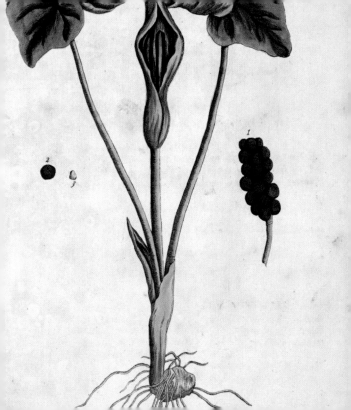

Cucumber · *Cucumis sativus*

This plant trails on the Ground, the Leaves are a Yellow-green, & the Flowers a pale Yellow.

It is raised from the Seed yearly; & flowers, & bears Fruit for several Months in the Summer.

The Seed is used for the Stone, Strangury, heat of Urine, burning Fevers and Plurisies. Dioscorides says, the Fruit chears decayed Spirits; and recommends the Leaves boiled with Wine, and mixed with Honey as a cure for the Bite of a Dog.

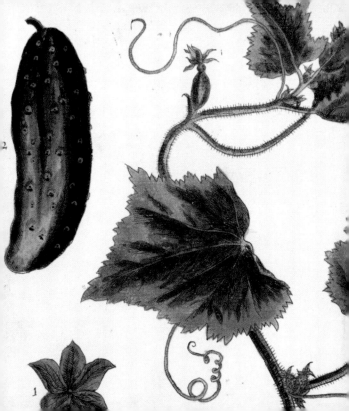

Damask Rose · *Rosa × damascena*

[*Rosa Damascena*]

This Rose Bush grows not so tall as the white, but taller than the Red; the Leaves are a light Grass Green, and the Flowers a pale Red.

It grows in Gardens and flowers for several Months in the Summer.

The Flowers are of a gentle cathartic Nature, purging choleric and serous Humors.

They are frequently given to Children & weakly Persons, mixt with stronger Cathartics.

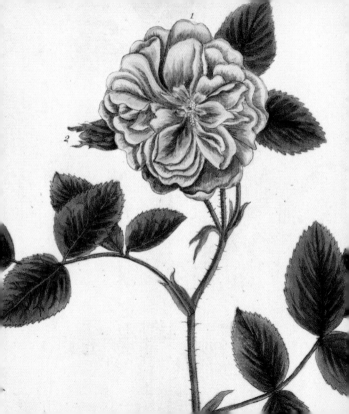

Dandelion · *Taraxacum officinale*

[Dandelion, or Piss-a-bed, *Dens Leonis*]

The Leaves of this Plant lie on the Ground; the Pedikels or Pipes on which the Flowers grow are about six or eight Inches high; and the Flowers yellow. The Root grows about a Finger thick, and eight Inches long, full of a white bitter Milk.

It grows almost every where in Fallow Ground, & flowers most Months in the Year.

The Roots & Leaves are used, as cooling, aperative, provoking Urine, & strengthening the Stomach, and are much eat as a Sallad in the Spring.

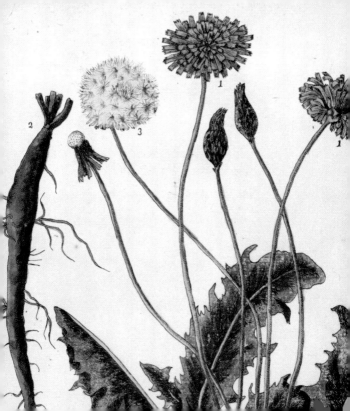

Dittany of Crete
Origanum dictamnus
[Dittany of Creet, *Dictamnus Creticus*]

The Stalks grow about a Foot high, the Leaves are a pale Green covered with Wool, except those on the young Stalks next the Top, which have no Wool; & the Flowers are a light Purple.

It grows chiefly in the Island of Creet or Candy, & flowers in June.

This Plant was had in great Esteem among the Ancients, particularly Virgil, for its reputed Virtue of expelling the Arrows from wounded Bodies. It is still accounted alexipharmic, resisting Poison and all contagious pestilential Diseases; and is esteem'd good for the Bites or Stings of Venemous Creatures. It is of great Use to accelerate the Birth, expelling the Secundines and procuring the Catamenia. There is a good Quantity of it put into the Venice-Treacle, Mithridate and Diascordium. The Leaves are the only Part used.

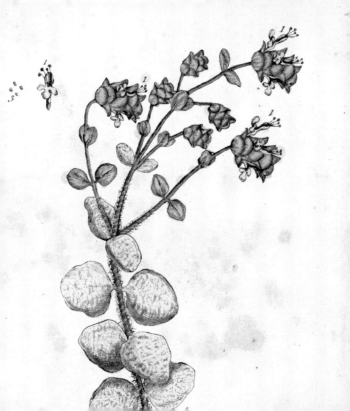

Dog Rose · *Rosa Canina*

[Wild Rose or Briar Rose]

The Leaves are a darker green than the Garden-rose; and the Flowers are sometimes white, but oftener a pale Red.

It grows in Hedges, & Flowers in June & July. The Hips are fit to gather the latter End of September. On the Stalks of this Bush the Bedeguar grows, which is a redish green spongy hairy Excrescence, made by small Ichneumon Flies. See Ray's Catalogue of the Plants about Cambridge, p. 140.

The Flowers of this Rose are thought more restringent than the Garden: Some look upon them as a specific for the Excess of the Catamenia. The Pulp of the Hips strengthens the Stomach, cools the Heat of Fevers, is pectoral, good for coughs, spitting of Blood & the Scurvy. The Seed is good against the Stone and Gravel. The Bedeguar is said to have the same Virtues. The officinal Preparation is, the Conserva Cynosbati.

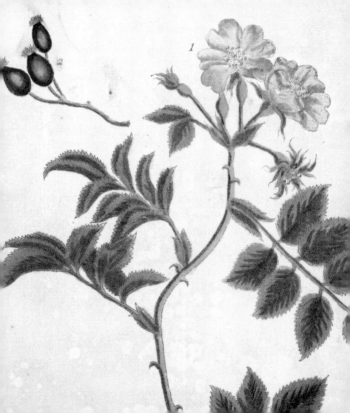

Dwarf Elderberry · *Sambucus ebulus*

[Dwarf-Elder, *Ebulus*]

It grows about four Foot high, the Leaves are a light Green, & the Flowers white, with a little Dash of Purple.

It grows near Motes and in Hedges; and flowers in May.

This much of the Nature of common Elder [see p. 92] being good to purge serous watery Humors by Stool, and is therefore good for the Dropsy and other Distempers arising from a Glut of Serum. It is also useful in Gouty scorbutic Humors, both given inwardly, and applyed outwardly, boiled in a Lixivium.

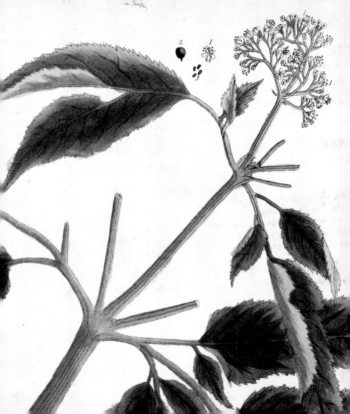

Dyer's Woad · *Isatis tinctoria*

[Woad, *Isatis*]

The Stalks grow about three or four Foot high, the Leaves are a willow Green, and the Flowers yellow.

It grows wild in several Parts of England, but is generally Sown for the Use of the Dyers; and flowers in May.

Woad is esteem'd restringent & drying, and is good to stop inward & outward Bleedings. Some commend it much for Ruptures & Strains, and to strengthen the Joints. It is an Ingredient in the Emplastrum ad Herniam.

Elderberry · *Sambucus nigra*

[Elder, *Sambucus*]

This is a common Hedge Tree, & seldom grows to any great bigness. The Leaves are a light grass Green, the Flowers white, and the Berries a deep purple.

It grows frequently in Hedges near Ditches, and flowers in May the Berries being ripe in September.

The Bark, Leaves, Flowers & Berries are used. The inner Bark is much used for the Dropsy. The Leaves outwardly are good for Inflammations, St. Anthony's Fire & the Piles; the Flowers are used for the same, and are also put in Fomentations & Cataplasms for all kinds of Swellings, Tumours, & Pains in the Limbs: inwardly they expell Wind, & help the Cholic. The Berries are cordial & useful in histeric Disorders. On the Trunk of this Tree grows an Excrescence which they call Jews Ears, being accounted good for the swelling & Inflammation of the Tonsils, sore throats and Quinseys.

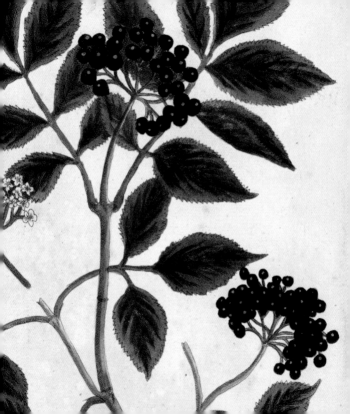

English Walnut · *Juglans regia*

[The Wallnut, *Juglans*]

This grows to be a large Tree, the Leaves are a yellow Green, & the Catkins yellowish.

It is planted in Walks, Parks & Fields; and the Catkins come out in April.

The Bark is accounted a strong Emetic; either Green, or dryed and powdered. The Green Nuts are cordial & alexipharmic being of great Use in all contagious malignant Distempers, & even the Plague; they are one of the Principal Ingredients in the Treacle Water. The Nuts preserved are good to be eat in a Morning to prevent Infection in the time of Pestilential Distempers. Two or three Ounces of the Oil express'd from the ripe Kernels, is a very good Medicine for the Stone and Gravel. The Shells powdered or burnt are accounted restringent.

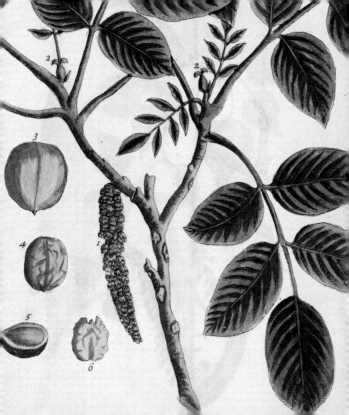

European Olive · *Olea europaea*

[The Olive Tree, *Olea* or *Olea sativa*]

This Tree grows to a great Bigness in its native Climate, the Leaves are a deep Green above & hoary underneath, the Flowers yellow, & the Fruit black when ripe.

It grows in Spain, Italy and Turky.

The Oil is moderately healing & mollifying, rendring the Body lax & soluble; it helps Disorders of the Breast & Lungs, & eases Gripings & the Collic. It is of great use against all corrosive mineral Poisons, as Arsenic, Sublimate &c. It opens the Urinary Passages & is good for the Stone & Gravel. The pickled Olives are grateful to the Stomach, and provoke an Appetite. The ripe Olives are a great Part of the Food of the Eastern Countries, among the Greeks; especially in Lent.

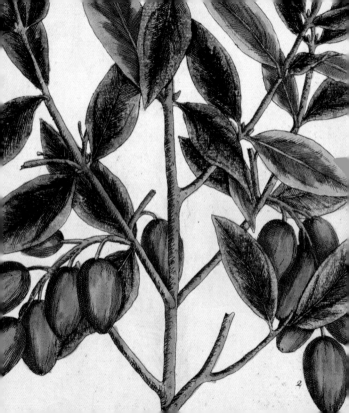

European Sanicle · *Sanicula europaea*

[Sanicle or Self-Heal, *Sanicula* or *Diapentia*]

The Stalks grow to be a Foot high, the Leaves are a bright grass Green, and the Flowers white.

It grows in Woods and Flowers in May.

This is one of the Chief vulnerary Plants, being frequently put into Wound-Drinks, and traumatic Apozems; and is esteemed good for Ruptures, inward Bruises, spitting of Blood, or any Haemorrhagies; and Wounds both inward and outward.

Eyebright · *Euphrasia officinalis*
[*Euphragia*]

The Stalk grows about eight Inches high, the Leaves are a deep Green and the Flowers white, with a yellow Spot in the Middle, and several black Stripes running lengthways.

It grows in Fields and Commons flowring in July.

This Plant is famous for all Disorders of the Eyes, especially for Dimness of Sight; and to strengthen it, when weak or decayed, either given in the Juice, or Decoction, or the Powder of the Leaves. A Powder made of two Ounces of Eyebright, and half an Ounce of Mace is very much commended for the above Ends; especially after proper Evacuations. Some esteem it good for the Jaundice. The Officinal Preparation is, the Aqua Euphrasiae.

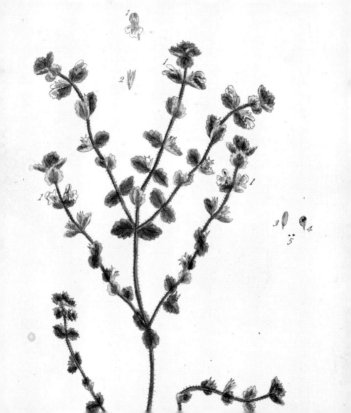

Feverfew · *Tanacetum parthenium*

[Featherfew, *Matricaria*]

The Stalks grow about two Foot high, the Leaves are a yellow Green, the Flowers white with a yellow Thrum in the Middle.

It grows in Hedges and Lanes, flowring in June and July.

This Plant is particularly appropriated to the Female Sex, being of great Service in all cold flatulent Disorders of the Womb and hysteric Affections, procuring the Catamenia, and expelling the Birth and Secundines. About two Ounces of the Juice, taken an Hour before the Fit, is good for all kinds of Agues. It also destroys Worms, provokes Urine, and helps the Dropsy and Jaundice.

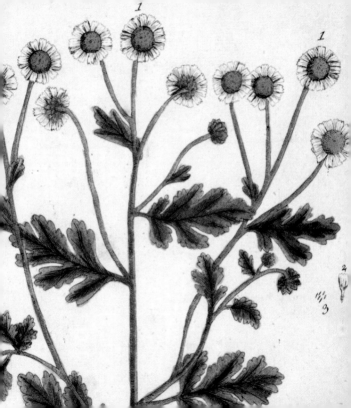

Foxglove · *Digitalis purpurea*
[*Digitalis*]

It grows to be three Foot high; the Leaves have a little Down upon them; the Flowers are red, spotted with white, and grow all on one side of the Stalks.

Fox-Glove grows in Hedges and Lanes, and flowers in June and July.

This Plant is but rarely used inwardly, being a strong Emetic working with Violence upwards and downwards. Parkinson extolls a Decoction of it in Ale, with Polipody Roots, as an approved Medicine for the Falling Sickness. The late Doctor Hulse commends the Ointment made of the Flowers and May Butter, for Scrophulous Ulcers which run much, dressing them with the Ointment and purging two or three Times a Week with proper Purges. The officinal Preparation is, the Unguentum digitalis.

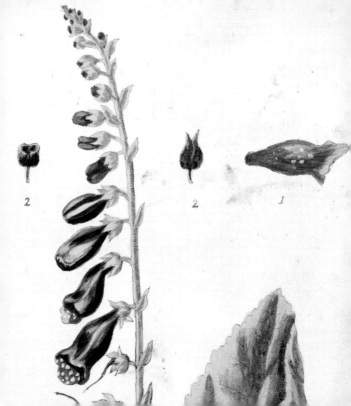

2

2

1

French Lavender · *Lavandula stoechas*

[Stechas, or French Lavender,
Stoechas arabica or *purpurea*]

This Shrub grows about three Foot high, the Leaves are a whitish Green, and the Flowers a deep Purple.

It grows naturally in Spain, and the Southern Parts of France, and is planted here in Gardens, flowring in April and May.

The Flowers are accounted cordial & cephalic, Strengthening the Genus Nervosum, and are usefull in Apoplexies. Palsies & Convulsions. They are also opening & attenuating, promoting the Catamenia and resisting Poisons.

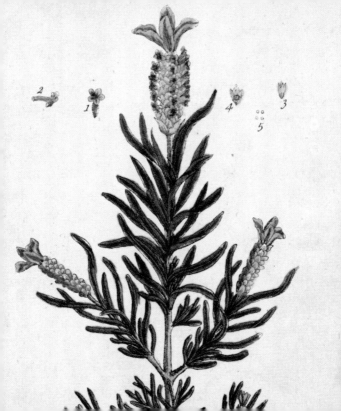

1 2 3 4 5

French Rose · *Rosa gallica*

[The Red Rose, *Rosa Rubra*]

This Rose Bush is less than the white or Damask; the flowers have very few Prickles on the stalks; the Leaves are a grass Green, and the Flowers a light Crimson.

It grows in Gardens and flowers in June and July.

The Red Rose is more binding and restringent than any of the Other species, & are esteemed good in all kinds of Fluxes. They Strengthen the Stomach, prevent Vomiting, stop tickling Coughs by preventing the Defluxion of Rheum, and are of great Service in Consumptions. The Apices are also accounted cordial.

The Officinal Preparations are a Simple Water, the Conserva Rosarum, Sacharum Rosarum, Syrupus & Rosis siccis, Mel Rosarum, Ol. Rosarum, Unguentum Rosarum, Tinctura Rosarum et Species Aromaticum Rosarum.

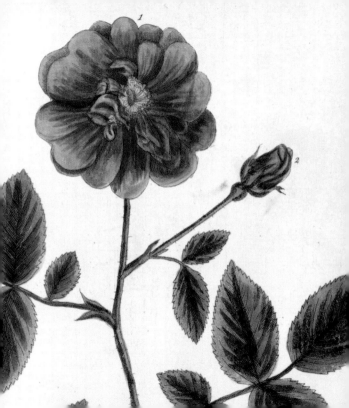

Garden Cress · *Lepidium sativum*

[*Nasturtium Hortense*]

It grows to be eighteen Inches high; the Leaves are a bright Green, & the Flowers white.

It is sown in Gardens yearly, and flowers most Months in the Summer.

The Leaves are much used as a Sallad, their warmth being good to help the coldness of others mixed with them. They are esteemed good for the Scurvy, Dropsy, Palsy and Lethargy. A Cataplasm of the Leaves with Hog's Lard cures scald Heads, the Seed helps the Scurvy and Dropsy, and swelling of the Spleen; and opens Obstructions in the Female sex, and prevents the falling off of the Hair.

Gas Plant · *Dictamnus albus*

[White Dittany or Fraxinella,
Dictamnus albus or *Fraxinella*]

It grows to be 2 foot high, the Leaves are a dark Green, and the Flowers red, & sometimes white.

It grows wild in several Places of France & Germany; but is planted here in Gardens, & flowers in June & July.

The Roots are esteem'd cordial and cephalic, good to resist Putrefaction and Poison, and useful in malignant and pestilential Distempers.

It is accounted good for Epilepsies & other Disorders of the Head. Opening Obstructions of the Womb, & procuring the Menses. The Preparations are the Aq. Antepileptic. Theriacal, Pulv. Liberans. Empl. Stipticum. Paracels.

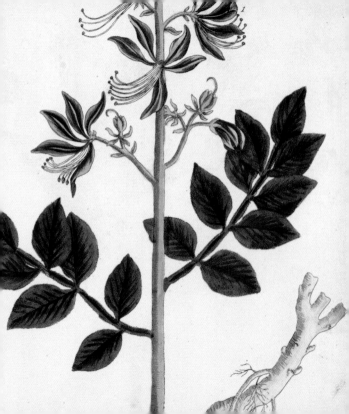

Ginger · *Zingiber zerumbet*

[Zerumbet, *Zerumbet*]

This Plant is not certainly known to be the Zerumbet of the Arabians; but that the Curious may have an Opportunity of enquiring more particularly into it. . . . It grows about 18 Inches high, the Roots are cream colour, the Stalk a whitish Green, the Leaves a deep Green above & light underneath and the Flowers whitish.

It grows in Ceylon in the East Indies.

The Roots are commended in the Malabar Garden, as good to quench all inward heat, purge the Reins, stop the Fluor Albus, and a Gonorrhea.

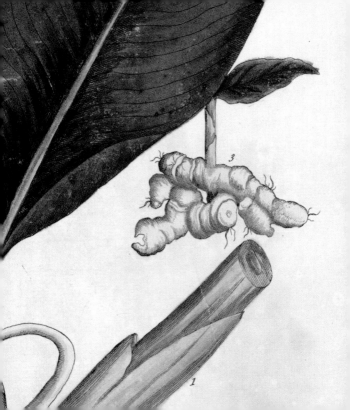

Goat's Rue · *Galega officinalis*

[*Galega*, or *Ruta capraria*]

The Stalks grow to be a Yard high; the Leaves are a grass Green; & the Flowers a pale Blue.

It grows in several Places of Italy wild; but is planted here in Gardens, and flowers in June and July.

Goat's Rue is esteem'd cordial, sudorific, alexipharmic, good against pestilential Distempers. It is also of use in most Fevers, the Small Pox and Measels. It kills Worms, and is good to cure the Bite of Venomous Creatures.

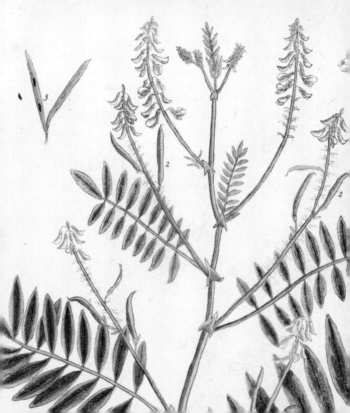

Great Burdock · *Arctium lappa*

[Bardana major. Lappa major]

The stalks grow to be two Foot high, the Leaves are white & hoary underneth, and a deep grass Green above, and the Flowers are Purple.

It grows by Way-sides and flowers in June and July.

The Roots are sudorific and alexipharmic, good in malignant Fevers, & are therefore used in the Aq. Theriacalis. They are accounted good against the Gout and Pains in the Limbs. The Leaves boil'd in Milk, and applied as a Cataplasm are by some used for the same Distemper; as also for Burns and Inflammations, and are one of the Ingredients of the Unguent Populneum. The Common People apply them often to the Feet & Wrists in Fevers. The Seed powder'd and given in white Wine is good to provoke Urine, and help Fits of the Stone.

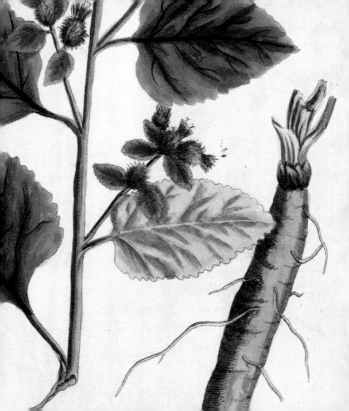

Greater Celandine
Chelidonium majus
[Great Celandine or Yellow-horn Poppy]

The Stalks grow to be a foot high, the Leaves are a bluish Green, and the Flowers yellow.

It grows among waste Grounds and Rubbish, and upon old Walls; it flowers in May and June.

It is accounted apperative and cleansing, opening Obstructions of the Spleen & Liver, & of great Use in Curing the Jaundice and Scurvy. Some reckon it cordial & good against pestilential Distempers. Outwardly for sore Eyes to dry up the Rheum, and to take away Specks, Films, Tetters, Ringworms & Scurfy Breakings-out.

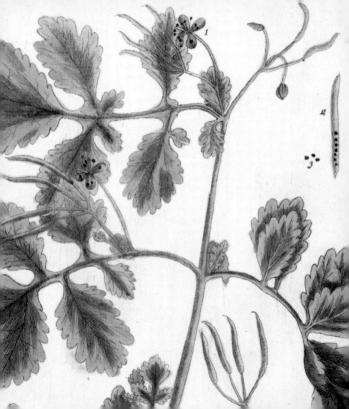

Green Tea · *Camellia sinensis*

[*Thea, & Thea Sinensis*]

This Shrub grows about five Foot high; the Leaves are a deep Green, and the Flowers a pale Red; this Specimen was taken from a Branch that Sr. Hans Sloan has.

It grows in China, and flowers for several Months in the Summer.

This Tea is accounted good to purify the Blood, promote Digestion, strengthen the Head, provoke Urine and prevent the Stone and Gout. But it must be drank moderately.

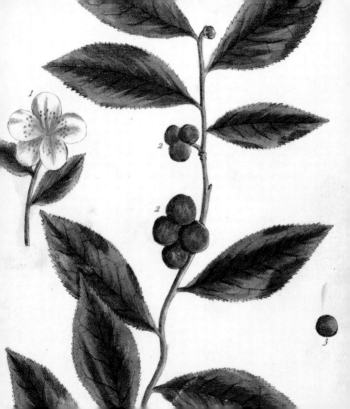

Gromwell · *Lithospermum officinale*

[Gromill, *Lithospermum*]

The Stalks grow about two Foot high, the Leaves are a grass Green, and the Flowers white.

It grows in dry Fields and Hedges, flowring in May.

The Seed is esteem'd a great diuretic, & a Cleanser of the Reins and Ureters, and good against the Stone, Gravel, Stoppage & Heat of Urine, as also a Gonorrhea. It is generally boil'd in Wine or Water. Matthiolus commends two Drams of the Powder to be given in Women's Milk, as a speedy help in hard Labour.

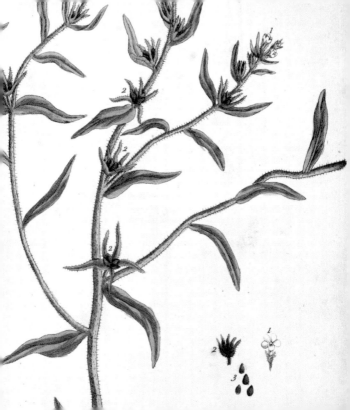

Heath Speedwell · *Veronica officinalis*

[Male Speedwell, *Veronica mas*]

This is a low creeping Plant; the Leaves are a light Green, and the Flowers a bluish Purple.

It grows in Woods and Shady Places, flowring in June.

This is esteemed a vulnarary Plant, being used both inwardly & outwardly. Some account it good for Coughs and Consumptions, the Stone, Stranguary, and pestilential Fevers.

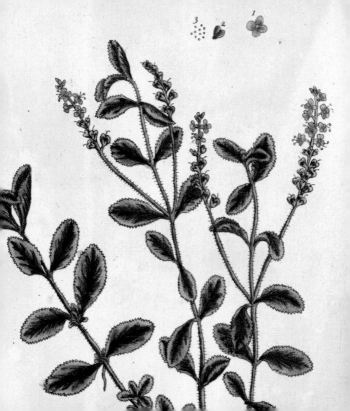

Hedge Mustard
Sisymbrium officinale
[*Erysimum*]

It grows to be two Foot high, the Leaves are a yellow Green, & the Flowers a pale Yellow.

Hedge-Mustard grows commonly by Way-sides, and on Banks, and flowers most part of the Summer.

This Plant is hot, dry, opens & attenuates; by its warming Quality, it desolves thick and slimy Humours in the Lungs, helps a Cough and shortness of Breath. It is much recommended against an habitual Hoarsness, to recover the Voice. Riverius praises a Decoction of it in Wine, as a good remedy for the Collic. The officinal Preparation is, the Syrupus de Erysimo.

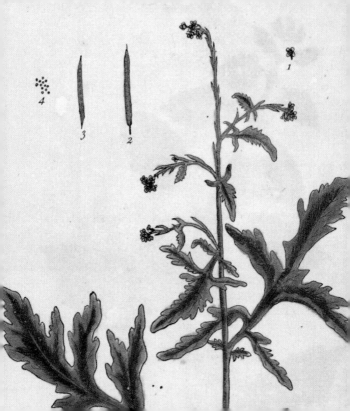

Hemp · *Cannabis sativa*

[The Female Hemp, *Cannabis foemina*]

The Stalks grow about five Foot high, the Leaves are a deep Green above and a light Green underneath.

It is planted in Fields and Gardens yearly, & produces its Seed in August; for this Species of Hemp never bears any visible Flower.

The Seed being boil'd in Milk, till it cracks, is accounted good for old Coughs, and a Specific to cure the Jaundice.

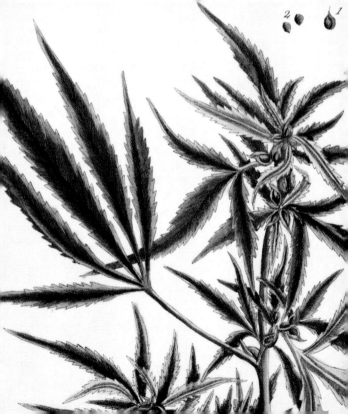

Hercules's All-heal
Opopanax chironium
[Panax Herculeum]

The Stalks grow about six or eight Foot high, the Leaves are a yellowish Green and the Flowers yellow.

It is a Native of Syria, and flowers in June.

The Gum opponax is said to come from the wounded Root of this Plant; and is accounted heating & dissolving, good to evacuate tough Phlegm from the remote Parts of the Body, & on that account is useful against old Coughs and Asthmas; it helps the Gout, Sciatica, & Rhematic Pains in the Limbs, and procures the Catamenia. Outwardly applyed it is good to dissolve hard Swellings, Tumors, pestilential Buboes, & Cure the Bitings of Venemous Creatures.

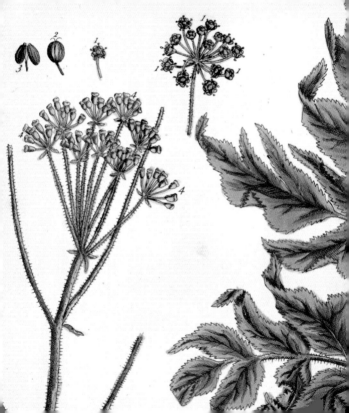

Hot Pepper · *Capsicum annuum*

[Guinea Pepper, *Capsicum. Piper indicum*]

The Stalks grow to be two Foot high, the Leaves are a deep grass Green, the Flowers white and the Fruit red.

It is sown in Gardens, and flowers in August; the fruit being ripe in September.

Some commend a Decoction of this with Penny Royal as good to expell a Dead Child. The Skins boil'd and used as a Gargle help the Tooth Ach. A Cataplasm of the Seeds powder'd and mixt with Honey applyed to the throat, is good for the Quinsey. It is much used as a Sauce for any Thing that is flatulent and Windy.

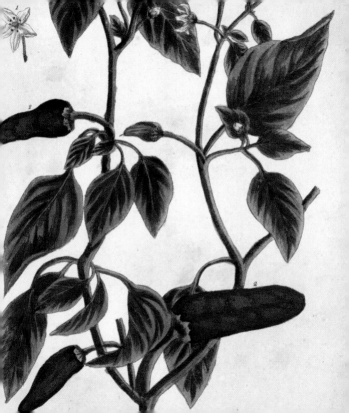

Hound's-tongue
Cynoglossum officinale
[*Cynoglossum*]

The Stalks grow two or three Foot high, the Leaves are a blue Green, and the Flowers red.

It grows by Hedges and the Sides of Roads flowring in May & June.

The Root is accounted cold, drying, & binding, good for Catarhous Defluxions upon the Lungs; and all kinds of Fluxes & Haemorrhagies, & a Gonorrhea. Some account it a vulnerary, & use it for scrophulous Tumors, taken inwardly; or applied outwardly as a Cataplasm. The Officinal Preparation is the Pilul. Cynogloss.

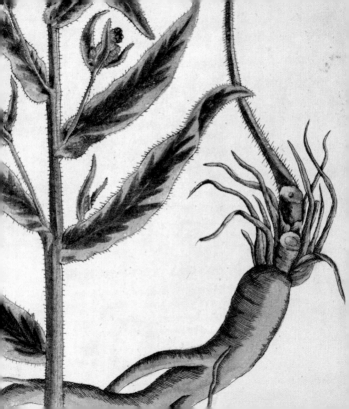

Hyssop · *Hyssopus officinalis*

[*Hyssopus*]

It grows about a Foot high, the Leaves are a grass Green, and the Flowers a fine Blue.

It is sown here in Gardens, and flowers in July.

It is accounted healing, opening and attenuating, good to cleanse the Lungs of tartarous Humors; and ease all Diseases of the Head and Nerves. The Herb bruised is famous to take black and blue Marks out of the Skin. The Officinal Preparation is, the Simple Water.

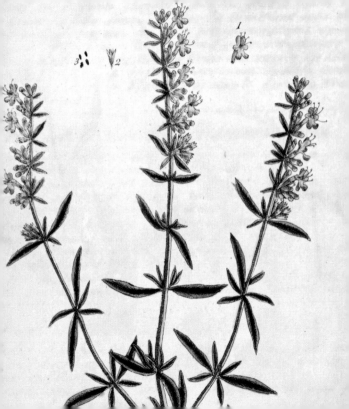

Jasmine · *Jasminum officinale*

[Jasmine, or Jessamine,
Jasminum or *Jasminum album*]

This Shrub shoots forth long slender green Twigs, which would lie on the Ground if they were not supported; the Flowers of the common Jasmine are white.

It is planted with us in Gardens, and flowers for several Months in the Summer.

The Flowers are the only Part used. Schroder commends them as good to warm & relax the Womb, to heal any Schirrthi therein, and to facilitate the Birth: and also for a Cough and Difficulty of breathing. The Oil made by Infusion of the Flowers is used in Perfumes. Matthiolus thinks that the Ointment made of Jasmine by the Ancients was not that Jasmine which we have now.

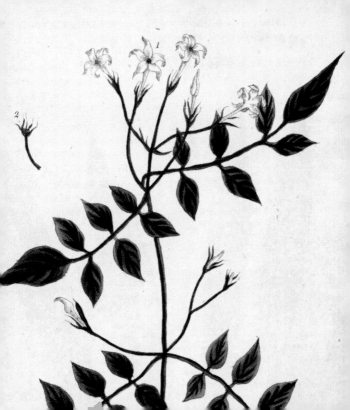

Johnny-jump-up · *Viola tricolor*

[Pansies or Heart's-Ease, *Viola tricolor.
Jaccea. Flos Trinitatis*]

It grows a Foot high, the Leaves are a dark Green, the Flowers spotted with a light Purple, a deep Purple and Yellow.

It grows Wild in the Borders of Fields, and is also planted in Gardens, flowring great Part of the Summer.

The Leaves are esteemed mucilaginous and vulnerary, good to take off the Gripes in Children, and prevent the Fits arising from them.

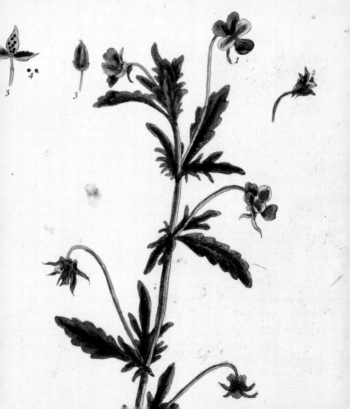

Lady's Bedstraw · *Galium verum*

[Ladies Bedstraw, *Gallium*]

The Stalks grow about two Foot high, the Leaves are a deep grass Green, and the Flowers a bright Yellow.

It grows on Banks and dry Barren Places, flowring in June & July.

Yellow Bedstraw is accounted drying and incrassating, good to stop all kinds of Fluxes & Haemorrhagies, and cure green Wounds. Some commend a Decoction of it for the Gout, and a Bath of it is very refreshing to wash the Feet after overwalking.

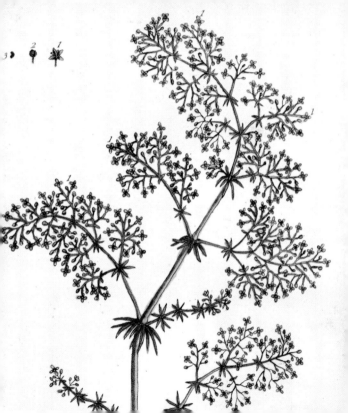

Lady's Mantle · *Alchemilla mollis*

[Ladie's mantle, *Alchimilla*]

It grows to be a foot high, the Leaves are a grass Green, and the Flowers a yellow Green.

It grows in Meadow and Pasture Grounds, and flowers in May.

This Plant is reckon'd a good vulnerary, being drying & binding, incrassating and consolodating, and of great Force to stop inward Bleeding, the immoderate Flux of the Menses, and the Fluor albus.

The Leaves applyed outwardly are accounted good for lank flagging Breasts, to bring them to a greater Firmness and smaller Compass.

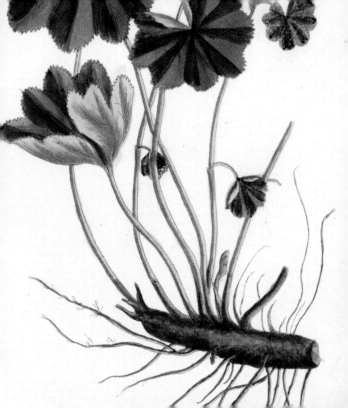

Lavender · *Lavandula angustifolia*

[*Lavendula*]

It grows about two Foot high, the Leaves are a light Green, and the Flowers bluish.

It grows wild in the Southern Parts of France and Spain, and is planted here in Gardens flowring in July.

Lavender is esteem'd cordial and cephalic, good for all Diseases of the Head and Nerves. It is also good to expell Wind from the Stomach and Bowels, and prevent the Collic. Outwardly it is used in Warming and strengthening Fomentations.

Lemon · *Citrus limon*

[The Lemon-Tree, *Limonia Malus*]

This Tree very much resembles the Orange Tree in its manner of Growth; the Leaves are a light grass Green, and the Flowers white.

It grows in Spain & Portugal & flowers for several Months in the Summer.

Lemons are cooling & grateful to the Stomach, and very useful in all sorts of Fevers; they are also good for the Stone & stoppage of Urine. The Juice mixt with Salt of Wormwood is accounted an excellent Medicine to stop Vomiting & strengthen the Stomach. The Officinal Preparation is, The Syrup of the Juice.

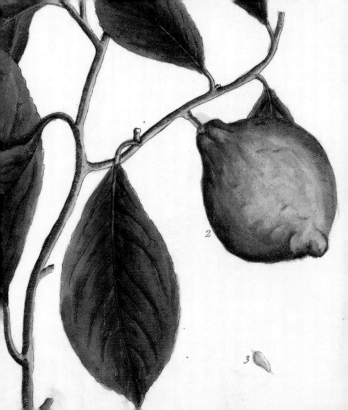

Lemon Balm · *Melissa officinalis*

[Balm, *Melissa*]

This Plant grows to be three Foot high; the Stalks are square, the Leaves a light yellow Green, and the Flowers white.

It grows only in Gardens here, and flowers in July and August.

The whole Herb is used, and esteemed cordial, cephalic, good for Disorders of the Head and Nerves, chears the Heart, cures its Palpitation, prevents Fainting, Melancholy, Hypochondriac, and Hysteric Disorders; resists Putrefaction, and is of great service in malignant and contagious Distempers; outwardly applied it helps the stinging of Bees and Wasps. The officinal Preparation is, the Simple Water.

Lesser Centaury
Centaurium pulchellum

[Lesser Centory, *Centaurium minus*]

This Centory seldome grows above a Foot high, the Leaves are a deep grass Green, and the Flowers a red Purple.

It grows in Fields & dry Pasture Grounds, flowring in June and July.

It is esteem'd cleansing and apperative, good to open Obstructions of the Liver and Spleen, provoke Urine and the Menses, help the Jaundice and intermitting Fevers, strengthen the Stomach and destroy Worms. Outwardly it is used in Fomentations against Swellings and Inflammations. The Officinal Preparation is an Extract.

Licorice · *Glycyrrhiza glabra*

[Liquorice, *Glycyrrhiza*]

The Stalks grow about three Foot high, the Leaves are a light grass Green, and the Flowers a pale Purple.

It is planted in Fields and Gardens, and flowers in June.

The Roots are pectoral, and of great Use in Distempers of the Lungs as Coughs and shortness of Breath; and likewise in nephritic Affections, as Stone, Gravel, stoppage & Heat of Urine, and Ulcers in the Kidneys.

Lignum Vitae · *Guaiacum officinale*

[Pockwood or Lignum Vitae, *Guajacum*]

This Tree grows about Thirty Foot high; the Leaves are a yellow Green, and the Flowers bluish; That Specimen mark'd . . . 3. 4. & 5. is taken from a young Plant in the Physick Garden which answers the Description of that which Sr. Hans Sloane calls the Porto Rico Sort.

The first Species grows in Jamaica, and the last in Brasile.

The Bark & Wood are good for the Dropsy, Gout, King's Evil and the Lues Venerea. The Gum is useful in Scorbutick Cases or any Breaking out of the Skin.

Lily-of-the-valley
Convallaria majalis

[Lillies of the Valley, *Lilium convallium*]

It grows to be 8 or 10 Inches high; the Leaves are a grass Green, and the Flowers white.

It grows in the Vallies, but chiefly in Gardens, and flowers in May and June.

Lillies of the Valley are of great service in all Disorders of the Head and Nerves; as Apoplexy, Epilepsy, Palsy, Convulsions, Vertigo.

They are much used in Errhines and cephalic Snuff.

A Large quantity of them are put in the Aqua Paeoniae C. and spirit. Lavendulae C. and the Aq. Antepileptica.

This Insect was travelling upon the Lilly, but it feeds commonly upon fruit Trees, & is called the Lackey from its variety of Colours.

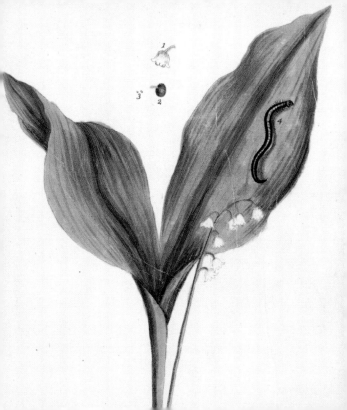

Madonna Lily · *Lilium candidum*

[White Lilly, *Lilium album*]

The Lilly grows about four Foot high; the Flowers are white, with yellow Apices in the middle.

It is planted in Gardens, and flowers in June and July.

The Flowers and Roots are used chiefly in external Applications; they are softning and anodine, good to dissolve and ripen hard Tumours and Swellings; and to break Imposthumations. Matthiolus recommends the Oil, made of the Flowers, as good for all Pains of the Joints & contracted Nerves. The officinal Preparation is, the Oleum Liliorum.

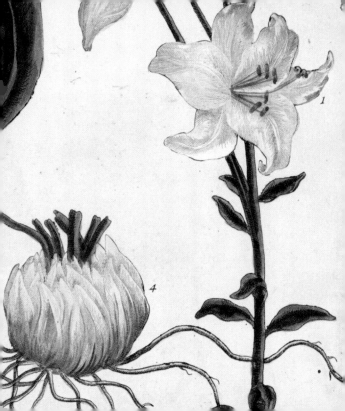

Mallow · *Malva sylvestris*

[*Malva vulgaris*]

Mallows grow to be three Foot high; the Stalks are somewhat hairy, & the Leaves are a yellowish Green, the Flowers are a bright reddish Purple, strip'd with a deep Purple.

It grows commonly by Way-sides, and flowers for most Months in the Summer.

This is one of the five emollient Herbs, being Loosening, Cooling & Molifying. A Decoction of the Leaves, sweetned with Syrup of Violets, & drank now and then to the Quantity of a Quarter of a Pint, keeps the Body soluble, asswages choleric Humours, allays the heat & sharpness of Urine, eases the Stone & Gravel, and provokes Urine. A Cataplasm made of the Leaves, eases the smart of the Place that is stung by Bees or Wasps. Where Marsh Mallows are not to be had this may supply the Place.

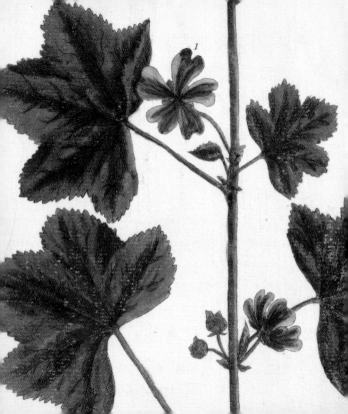

Marsh Mallow · *Althaea officinalis*

[Marshmallows, *Althaea, Bismalva, Ibiscus*]

The Stalks grow to be a Yard high; the Leaves are of a yellowish green Colour; the Flowers are a pale Red.

It grows in Salt Marshes, and flowers in July.

This Plant is mollifying, digesting and Soupling, of great use in the Strangury, Gravel, Stone, Heat of Urine, corroding Humors in the Stomach and Guts, Coughs, Hoarsness, Swellings & Inflamations.

Officinal Preparations are, the Syrupus de Althea, Pulv. Dialtheae & Unguentum Dialtheae.

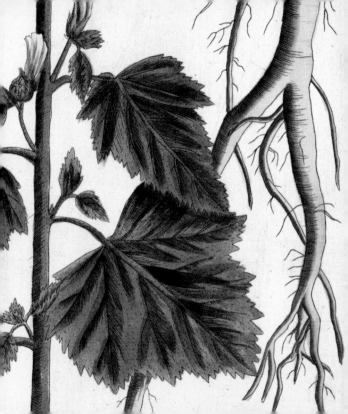

Marsh Woundwort · *Stachys palustris*

[Clown's-allheal, *Panax Coloni*]

The Stalks grow about three Foot high; the Leaves are a deep grass Green, and the Flowers a red Purple.

It grows in Ditches and watery Places, flowring in June.

Gerard gives this Plant great Commendations for a good vulnerary, to cure all green Wounds, beaten to a Cataplasm, with Hogs Lard. Some commend it for all kinds of Haemorrhagies.

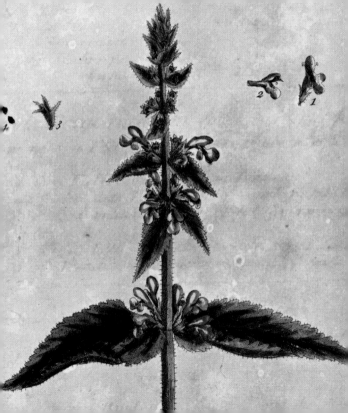

Meadowsweet · *Filipendula ulmaria*

[*Ulmaria*]

The Stalks grow about three Foot high; the Leaves are a bright Green above, and hoary underneath, and the Flowers a cream Colour.

It grows in moist Meadows, and by River-sides, flowring in June.

The Leaves & Tops are accounted alexipharmic & sudorific, and good in Fevers and all malignant Distempers; they are also restringent and binding, and usefull in all kinds of Fluxes. They are an Ingredient in the Aqua lactis. The Officinal Preparation is the Aqua Ulmariae.

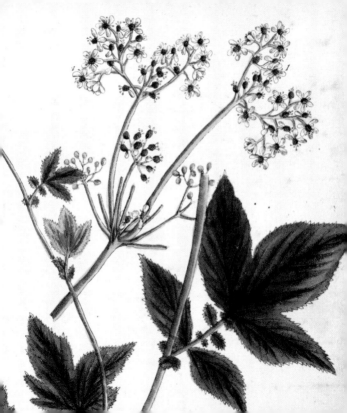

Melilot · *Melilotus officinalis*
[*Melilotus*]

The Stalks grow to be three foot high, the Leaves are a Grass-green, and the Flowers a light Yellow.

It grows frequently among the Corn and in Hedges, and flowers in June.

The Leaves and Flowers are accounted mollifying, discussing, dissolving and easing Pain; for which Uses they are put in Stupes and Cataplasms against Inflammations, hard Tumours, or any kind of Swellings.

The Melilot Plaster made of this Herb boiled in Mutton Suet, Rosin and Wax, is drawing, and good for green Wounds, but is chiefly used in Dressing of Blisters.

Officinal Preparations are the Emplastrum Meliloti Simp. & Comp.

This Caterpillar is called by some the Hussy; Doctor Muffet calls it the Sayl-Yard; it feeds upon most Green Plants.

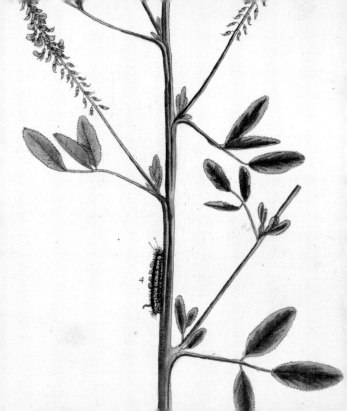

Motherwort · *Leonurus cardiaca*

[Motherwort or Marrubuim,
call'd Cardiaca, *Cardiaca*]

It grows to be eighteen Inches high; the Leaves are a dark Green on the Face and light on the Back, and the Flowers a red Purple.

It grows in Waste Places and Lanes, flowring in June.

This Plant, from a supposition that it relieves the Disorders of the Heart, as a Palpitation and Swooning, takes the Name of Cardiaca. Doctor Bowles has commended a Decoction of it sweetned with Sugar as a singular Remedy for the above Illness, and for Affections of the Spleen and Hysteric Fits.

The Powder given in Wine to the Quantity of a Dram is commended as a present Remedy to expediate the Birth.

Mugwort · *Artemisia vulgaris*

[*Artemisia*]

The Stalks grow about three Foot high; the Leaves are a deep Green above and hoary underneath, and the Flowers a purplish Yellow.

It grows in Hedges and waste Places, flowring in June.

The Leaves are chiefly used, especially against Distempers incident to the Female Sex, being of great service in promoting the menstrual Evacuations, either taken inwardly, or used outwardly in Baths & Semicupia. Some Recommend this Plant as good to strengthen the Head & Nerves, & help hysteric Fits or Vapours. The Moxa, so famous in the Eastern Countries for curing the Gout by Burning, is the Down of a lesser Species of Mugwort, viz the Artemisia Chinensis cujus Mollugo Moxa dicitur. The Officinal Preparation is the Syrupus Artemisia.

Mullein · *Verbascum thapsus*

[Mullein or Hig-Taper, *Verbascum*
or *Tapsus barbatus*]

It grows to be six Foot high, the Leaves are a light Willow-green, & the Flowers a pale Yellow.

They grow in Highways and Commons, and flower in July.

The Leaves are used for Coughs, Pains in the Breast, and Collic-Pains; & outwardly in Fomentations, and are thought a specific against the Piles. Dioscorides recommends a Decoction of the Root as good for the Tooth-ach.

Narrowleaf Plantain
Plantago lanceolata

[Narrow-leaved Plantain, or Ribwort,
Plantago angustifolia, or *Quinquenervia*]

It grows to eight or nine Inches high; the Leaves have five Nerves which run quite thro' them from the Root; the Flowers are of a light Umber colour with white Apices.

It grows in Fields and Meadows, and flowers mostly in May and June, altho' you may find some of it in Flower most Months of the Summer.

It is cold, dry and binding; good in all kind of Fluxes and Haemorrhages as spitting or vomitting of Blood, bleeding at the Nose, the Excess of the Catamenia or Lochia. It stops the involuntary making of Urine, eases its Heat & Sharpness, & the Gonorrhea, & stops the bleeding of Wounds. The officinal Preparation is, the simple distilled Water.

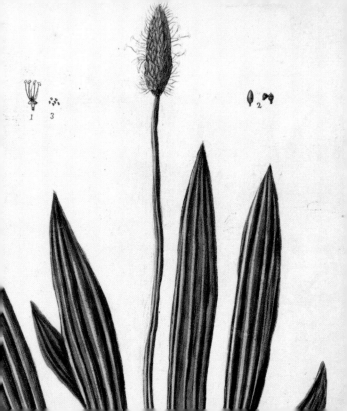

Nutmeg · *Myristica fragrans*

[*Nux Moschata*]

This Tree grows as big as a Pear-Tree, the Leaves are a grass Green and the Flowers yellowish; which are succeeded by Fruit as big as a Peach, whose outward Covering is soft and juicy like that of a Walnut, under which lies the Mace, firmly sticking to the hard Woody Shell; that contains the Nutmeg of the Shops. This Specimen is taken from Sr. Hans Sloan's Collection, but the unripe and ripe Fruit are taken from some that Mr. Rand had preserved on the Island, and are as large as the Life.

It grows chiefly in Banda, an Island in the East Indies.

Nutmegs are heating, drying and carminative; good to strengthen the Stomach and Bowels, stop Vomiting, help Digestion, comfort the Head & Nerves, prevent Swooning, & Miscarriage. The Mace has much the same Qualities but more penetrating; & is also accounted good for the Sight & to strengthen the Memory.

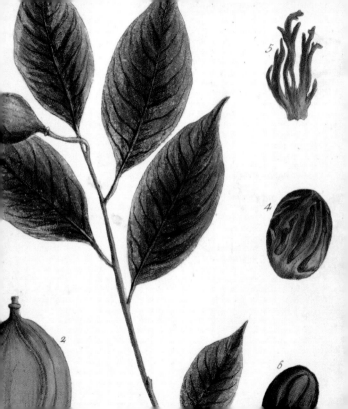

Oat · *Avena sativa*

[*Avena*]

The Stalks grow about four Foot high, the Leaves are yellowish when ripe, and the Flower is Green.

It is sown in the Fields in March or April, and is ripe in July and August.

Oats are restringent and drying; and Oatmeal is of great Service both in Health and Sickness, being a wholesome and cleansing Food. Water Gruel made thereof is much used in all Kinds of Distempers. Oats fried and put into a Bag, and applied to the Side, are good to ease pleuretic Pains; and applied to the Belly they help the Collic and Pains in the Bowels.

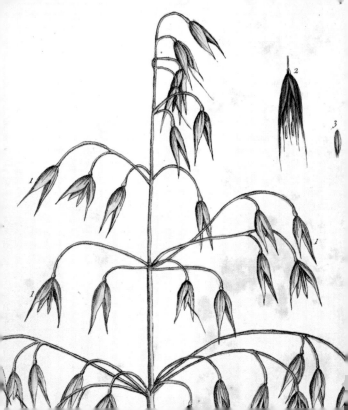

Parsley · *Petroselinum crispum*

[*Apium hortense* or *Petroselinum vulgare*]

It grows to be two Foot high; the Leaves are a light grass Green and the Flowers white.

It is sown in Gardens, and flowers for several Months in the Summer according to the time it is sown.

The whole Plant is opening, attenuating, diuretic, usefull for Obstructions of the Liver and Spleen, helps the Jaundice, provokes Urine, and eases the Stone, Gravel and Strangury. The officinal Preparation is, the Simple Water.

Pennyroyal · *Mentha pulegium*

[*Pulegium*]

It grows about a Foot high, the Leaves are a dull grass Green, and the Flowers a pale Purple.

It grows upon moist Commons, and flowers in July.

This plant is esteem'd a good Uterine, provoking the Menses and Lochia, expelling the Birth and Secundines. It also warms and comforts the Bowels, helps the Collic, Jaundice and Cough. The Officinal Preparations are, the distill'd Water, and Oil.

Peony · *Paeonia officinalis*
[The Female Piony, *Paeonia faemina*]

It grows 2 or 3 foot high, the Leaves are a grass Green, & the Flowers a fine Crimson.

It is cultivated in Gardens, and flowers in April and May.

This Plant generally supplies the Place of the Male Piony; and is accounted good for the Epilepsy, Apoplexy, and all kinds of Convulsions and nervous affections, both in young & old. Some recommend it in histeric Cases, the Obstructions of the Menses, and the Retention of the Lochia. The Root and Seed are hung about Children's Necks to prevent Convulsions in breeding their Teeth.

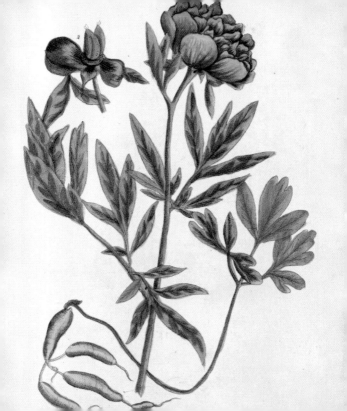

Peppermint · *Mentha × piperita*

[*Mentha Piperis sapore*]

The Stalks grow about two Foot high, the Leaves are a grass Green, and the Flowers a pale Purple.

It grows wild in Hertfordshire and Essex, and flowers in July.

It is accounted by some an excellent Remedy against the Stone and Gravel, which seems to be very probable; for besides its hot biting Taste, it has a nitrous one.

Pomegranate · *Punica granatum*

[Pomgranates, *Granata, Punica mala*]

The Pomgranate Tree which bears Fruit produces a single Flower of the same Colour as the double; and the Tree it self differs very little from the other.

This Tree, as well as the other, grows in Spain, Italy, and the warm Countries.

The single Flowers are drying and restringent, good for Hemorrhagies & Bleedings both inward and outward. The Fruit is gratefull and strengthning to the Stomach; stops Looseness and the immoderate Flux of the Terms; and is usefull in hot biliose Fevers, and Gonorrheas.

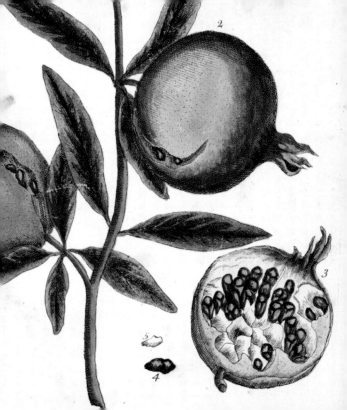

Poppy · *Papaver rhoeas*

[Red, Wild, or Corn Poppy, *Papaver rubrum*]

This Plant grows to be 2 Foot high, the Leaves are a Willow-green, & the Flowers Scarlet.

It grows in most Corn-fields, and flowers in June and July.

The Flowers of this Poppy are cooling, incline to sleep, & much used in inflamatory Fevers. Officinal Preparations from it are, the simple Water, the Syrup, the Conserve of the Flowers & the Tincture.

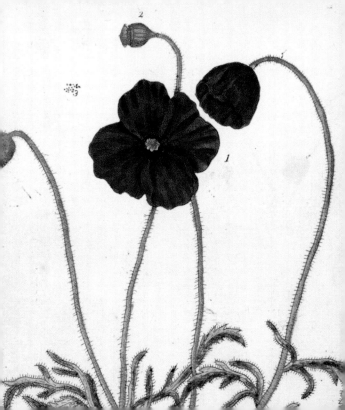

Pot Marigold · *Calendula officinalis*

[Marygolds, *Calendula*]

The Leaves are a light Green and the Flowers Yellow.

It grows in Gardens, and flowers great part of the Summer.

The Leaves and Flowers are accounted Cordial, Alexipharnice, good in all kinds of Feavers; they promote sweat and are frequently used to drive out the small Pox and Measles. Some commend them for the Jaundice, sore Inflamed Eyes, and Warts.

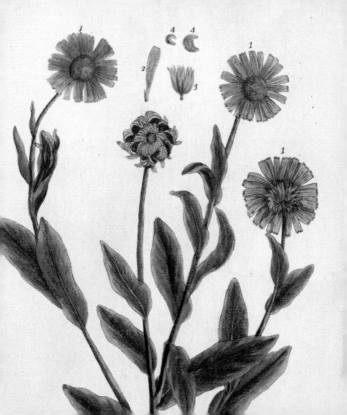

Primrose · *Primula vulgaris*

[*Primula Veris*]

The Stalks grow to be eight or ten Inches high; the Leaves are a grass Green, & the Flowers a pale Yellow; and the Roots a reddish Purple.

It grows in Thickets, and under Hedges, and flowers in March and April.

The Flowers are commended as good against Disorders arising from phlegmatic Humours. The Juice of the Root is used as an Errhine to purge the Head of tough slimy Phlegm.

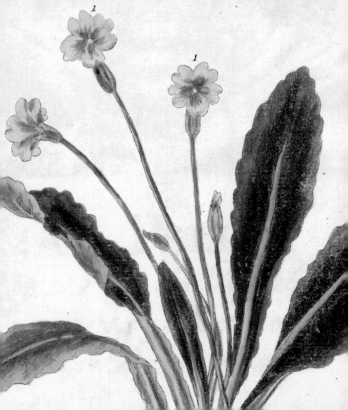

Quince · *Cydonia oblonga*

[*Cydonea*, or *Mala cotonea majora*]

This Tree seldom grows so big as the apple Tree, having useally a crooked Body, with many weak Branches. The Leaves are like those of the apple Tree, but rounder and whitish underneath: the Blossomes are a whitish Purple, and the Fruit a yellow Green, covered with a Down.

It is commonly planted by Ponds and Moats, flowring in May, the Fruit being ripe in September and October.

The Fruit is accounted cordial and strengthning to the Stomach, helping Degestion, and Stopping Vomiting & the Hiccough. They are also esteemed good for all sorts of Fluxes. The Seed is balsamic and mollifying, tempering the Acrimony of Humors & serviceable against sore Mouths, Throats, and a Thrush; for which a Mucilage made of them is frequently prescribed. Outwardly it is applyed to heal sore chop'd Nipples.

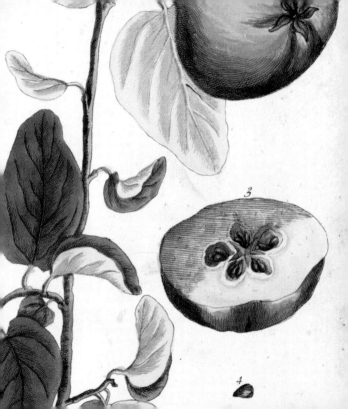

3

4

Roman Nettle · *Urtica pilulifera*

[*Urtica Romana*]

It grows about a Foot & an half high; the Leaves are a deep grass Green, and the Flowers a dull yellow.

It grows frequently about Yarmouth and Romney Marsh, and flowers in July.

This is much of the Nature of the common Nettle [see p. 240] but the Seed is accounted a better Pectoral, and of greater Service against Coughs and Affections of the Lungs.

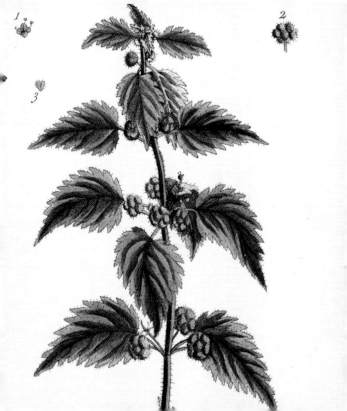

Root Chicory
Cichorium intybus var. *sativum*

[Garden Succory, *Cichorium sativum* or *Seris*]

It grows to be a Yard high, the Leaves are a grass Green and the Flowers blue.

It is planted in Gardens and flowers commonly in June and July.

Most of the Ancients say that this Plant is cold, but its Bitterness shews it to be hot; and is esteem'd aperative, diuretic, opening Obstructions of the Liver, & helping the Jaundice. It also provokes Urine, and cleanses the Urinary Parts of slimy Humors. The Officinal Preparation is, the Syrupus de Cichorio cum Rhabarbaro.

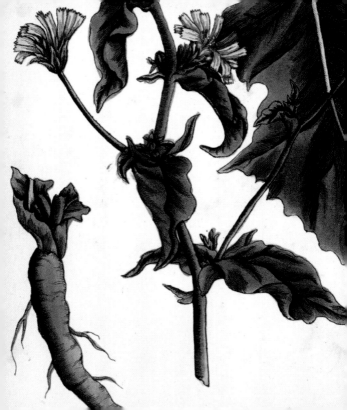

Rosemary · *Salvia rosmarinus*

[*Rosmarinus*]

This Shrub grows larger in England than in most Countries; the Leaves are hoary underneath and a dark green above, and the Flowers a pale Purple.

It grows wild in Spain & the Southern Parts of France; but it is planted here in Gardens flowring in April.

It is accounted good for affections of the Head & Nerves. It strengthens the Sight and Memory, and opens Obstructions of the Liver & Spleen. The Dried Herb burnt is good to sweeten the Air. Officinal Preparations are, Conserva Anthos, Aqua Reginae Hungariae, the Chymical Oil and fix'd Salt.

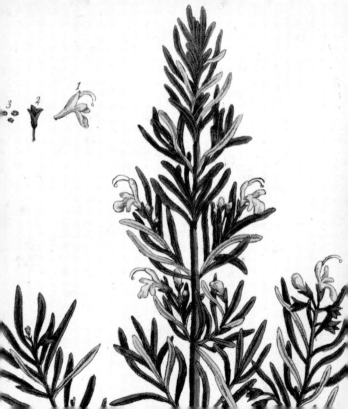

Rue · *Ruta graveolens*

[*Ruta*]

The Leaves are a Willow-green, and the Flowers yellow; the Stalks grow about two Foot high.

It is planted in Gardens and flowers in June and July.

The Leaves and Seed are used, being esteem'd alexipharmic, good against all infectious and pestilential Diseases, and all kind of Fevers; it eases Disorders of the Head, Nerves, Womb, convulsion and Histeric Fits, the Collick, Weakness of the Stomach and Bowels, it repells Poison, and Cures the Bite of venomous Creatures and mad Dogs. It is an Ingredient in the Aqua Brion. comp. and the Aqua Theriacalis. The officinal Preparations are the simple Water, Conserve of the Leaves, and an Oil by Decoction.

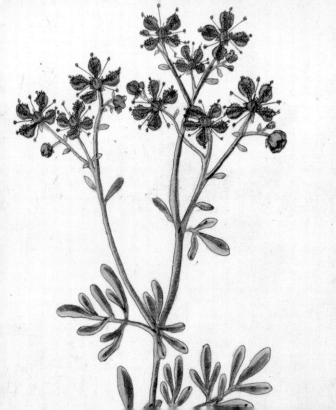

Saffron Crocus · *Crocus sativus*

[Saffron, *Crocus*]

The Stalks grow four or five Inches above Ground; The Leaves are a dark grass Green, and the Flowers purple; with red Stamina, which is the Saffron of the Shops.

The best Saffron grows in Essex, Suffolk and Cambridge-shire: it flowers in September and October.

Saffron is esteemed a great Cordial, strengthening the Heart & vital spirits, resisting Putrefaction, & usefull in all Kinds of malignant & contagious Distempers, Fevers, Small Pox, & Measles. It opens obstructions of the Liver & Spleen, helps the Jaundice, brings down the Catamenia, expediates the Birth & expells the Secundines. It is also good in Diseases of the Lungs, as Asthmas, or Consumptions. Outwardly in Poultices it eases Pains, & ripens Imposthumations.

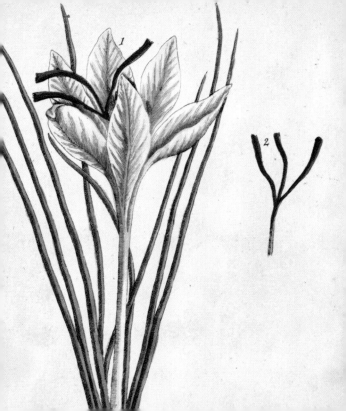

Sage · *Salvia officinalis*

[*Salvia*]

It is planted in Gardens; the Leaves are sometimes a hoary Green, & sometimes a reddish Purple; the Flowers are a bluish Purple; and grows about 18 Inches high.

It grows best in dry sharp Ground, and flowers in May and June.

The Leaves and Flowers are used, as good for all Diseases of the Head and Nerves; they are also diuretic, and good for Obstructions of Urine; and much used in all Sorts of Fevers, in Tea or Posset Drink.

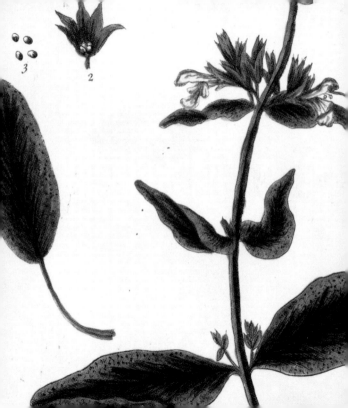

3

2

Saint-John's-Wort
Hypericum perforatum
[*Hypericum*]

This Plant grows to be two Foot high; the Leaves when held up against the Light appear full of small Holes; the Flowers are bright Yellow, with a great Number of Apices & Stamina, which being bruised between the Fingers emit a bloody Juice.

It grows in Hedges and among Bushes, and flowers in June and July.

St. John's Wort is accounted aperative, detersive, diuretic, alexipharmic; good in tertian and quartan Agues; destroys Worms, and is an excellent vulnerary Plant. A Tincture of the Flowers in Spirit of Wine is commended against Melancholy & Madness. Outwardly it is of great Service in Bruises, Contusions & Wounds, especially in the nervous Parts. The official Preparations are, the simple and compound Oil.

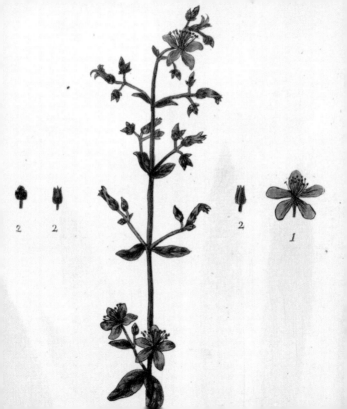

2 2 2 1

Scarlet Pimpernel
Lysimachia arvensis

[Pimpernel or Male Pimpernel,
Anagallis terrestris mas]

It grows to be a Foot high, the Leaves are grass Green and the Flowers scarlet.

It grows in Corn Fields flowring in May and June.

This Plant is moderately warm & dry with a little stipticity, and by some is accounted a good vulnerary. The Juice taken inwardly, (by it self, or mix'd with Cow's Milk) is good in Consumptions and Distempers of the Lungs.

It is often put in Cordial Waters as alexipharmic, & good against malignant Distempers. Some Writers of Note have recommended it in Cases of Lunacy and Dilerious Fevers. Matthiolus commends the Juice, for the Tooth-Ach; snuffed up the Nostril on that Side where the Pain does not lie.

Scurvygrass · *Cochlearia officinalis*

[*Cochlearia Batava*]

The stalks grow to be eight or nine Inches high, the Leaves are a grass Green, and the Flowers white.

It grows wild in the North of England by the Sea Side, but is very much cultivated in Gardens, and flowers in April.

This Plant abounds with fine volatile Parts, and therefore the Herb infused or the Juice express'd, is more prevalent than a Decoction, the volatile Parts flying away in the Boiling, and is accounted a Specific Remedy against the Scurvy Cleansing and purifying the Juices of the Body from the bad Effects of that Distemper, and clearing the Skin from Scabs, Pimples & foul Eruptions. Officinal Preparations are, The Simple Water, The Spirit, and a Conserve.

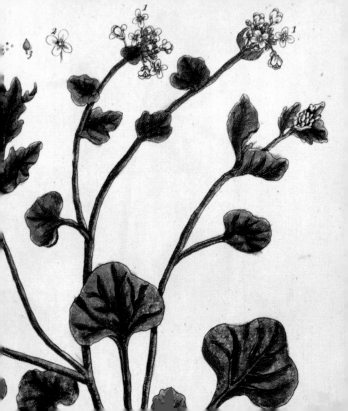

Self-Heal · *Prunella vulgaris*

[*Prunella* or *Brunella*]

This Plant grows to be a Foot high, the Leaves are a dark Green, and the Flowers Purple.

It grows in Meadows and pasture Grounds, flowering all the latter Months of the Summer.

It is used for all Inflammations and Ulcers in the Tongue, Jaws and Throat, either the Juice or a strong Decoction, as also for inward Bleedings & making of Bloody Water.

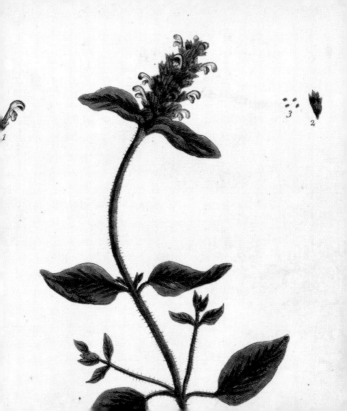

Shepherd's Purse
Capsella bursa-pastoris

[*Bursa Pastoris*]

The lower Leaves lie flat upon the Ground; the Stalk grows about a Foot high, and the Flowers are White.

It grows among Rubbish Banks and Walls, and flowers all the Summer.

This Plant is esteemed cooling, restringent, incrassating, & good in all sorts of Fluxes & spitting of Blood, bleeding at the Nose; the too great Flux of the Catamenia, violent Floodings, & bloody Urine.

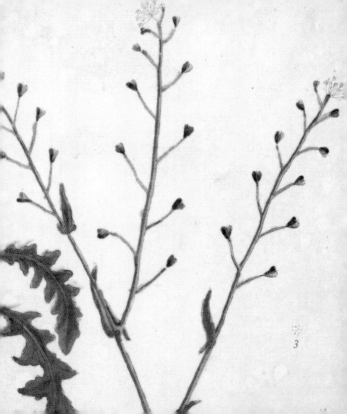

3

Shining Cranesbill
Geranium lucidum

[Doves-foot, or Crane's Bill,
Geranium Columbinum, or *Pes Columbinus*]

This Species of Crane's Bill grows a foot high, the Leaves at the Bottom spread on the Ground, and are a bright Green; the stalks are a Reddish Green, and the Flowers a red Purple.

It grows on Banks and Flowers great Part of the Summer.

It is esteemed a vulnerary Plant, usefull in inward Wounds, Bruises and Haemorrhagies, and all Fluxes. It is much cry'd up for the Cure of Ruptures in Children, given in Pouder. It also helps the stone and provokes Urine.

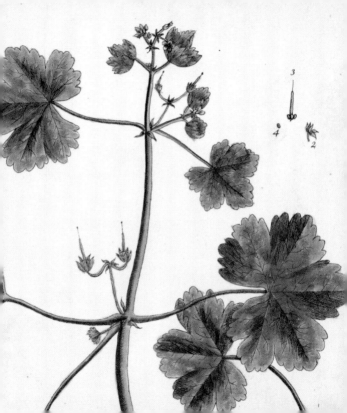

Silverweed · *Argentina*
(*Potentilla*) *anserina*

[Wild Tansie, or Silver-weed,
Argentina or *Potentilla*]

This Plant creeps upon the Ground, emiting Fibers from the Joints, by which it roots in the Earth and spreads; the Leaves are a light green covered as it were with a silver Down, and the Flowers yellow.

It grows in moist barren Ground where Water has stood all the Winter & flowers commonly in May or June.

The Leaves are restringent and vulnerary, good to stop all kinds of Fluxes & preternatural Evacuations; to dissolve co-agulated Blood, to help those who are bruised by Falls; outwardly it is used as a cosmetic to take off Freckles, Sunburn and Morphen and is good in restringent Gargarisms.

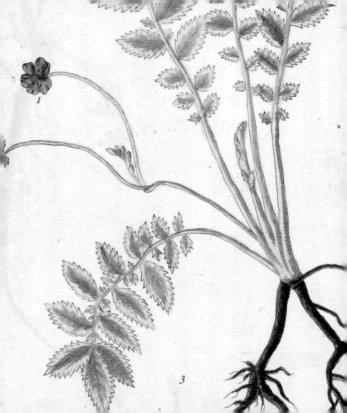

1

3

Sloe · *Prunus spinosa*

[The Sloe-tree, *Prunus sylvestris*]

It grows to be eight or ten Foot high, the Leaves are a deep grass Green and the Flowers white.

It grows common in Hedges, and flowers in March.

The Fruit is esteemed restringent and binding, good for all kinds of Fluxes and Haemorrhagies. It is of great service in Gargarisms for sore Mouths and Gums; and good to fasten loose Teeth. The Juice of the Sloes, boiled to a Consistence is what is now used for the true Acacia Germanica of the Shops.

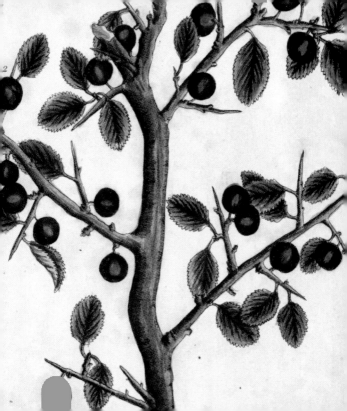

Soapwort · *Saponaria officinalis*

[Sopewort or Bruisewort, *Saponaria-vulgaris*]

It grows to be a foot and an half high, the Leaves are a grass Green, and the Flowers a pale Purple.

It grows in Watery Places near Rivers and flowers for several Months in the Summer.

It is called Saponaria, or Sopewort, because its Juice will get greasy Spots out of Cloaths. It is esteemed opening and attenuating and somewhat sudorific. It is recommended by some against the Lues Venerea. Outwardly applied it helps hard Tumours and Whitlows.

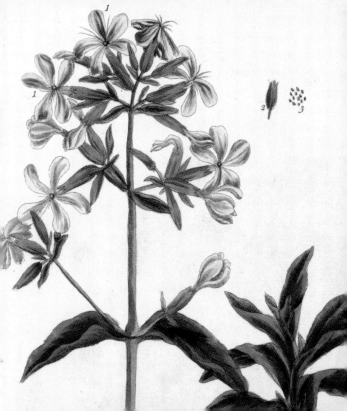

Sorrel · *Rumex acetosa*

[*Acetosa*]

The Stalks grow eight or ten Inches high, the Leaves are a grass Green, and the Flowers small and Staminous.

It grows in Fields and Meadows, flowring in May.

The Leaves are accounted cooling and cordial and very good in Fevers, resisting Putrefaction. The Root is esteem'd serviceable in the Scurvy & bilious Fluxes. The Seed is restringent, & is put into Diascordium & other binding Medicines.

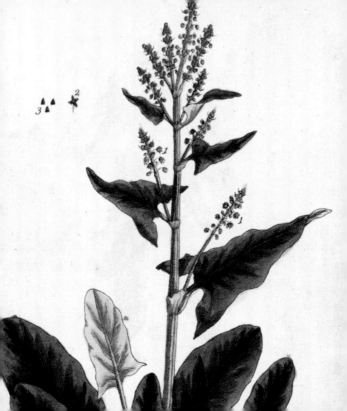

Spearmint · *Mentha spicata*

[Mint, *Mentha*]

The Stalks grow to be two Foot high in rich Ground; the Leaves are a yellow green, and the Flowers a pale Purple.

It is planted in Gardens, and flowers in July.

This Plant is esteem'd good for all Disorders of the Stomach, a Gonorrhea, the Fluor albus, & the immoderate Flux of the Menses. Officinal Preparations are, a Simple Water and Spirit, a Compound Syrup and a Distill'd Oil.

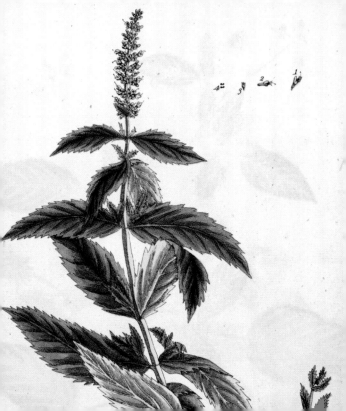

Spotted Lungwort
Pulmonaria officinalis
[*Pulmonaria maculosa*]

The Stalks grow near a Foot high, the Leaves are a deep Green, and spotted above; and a pale Green without Spots underneath; and the Flowers a dull red and a blue purple on the same Stalk.

It is planted in Gardens, and flowers in March and April.

The Leaves are accounted pectoral and balsamic; good for Coughs, Consumptions, spitting of Blood, and the like Disorders of the Lungs. They are also put into Wound-Drinks and traumatic Decoctions, being agglutinating, and good to heal Wounds, Ulcers, and old Sores.

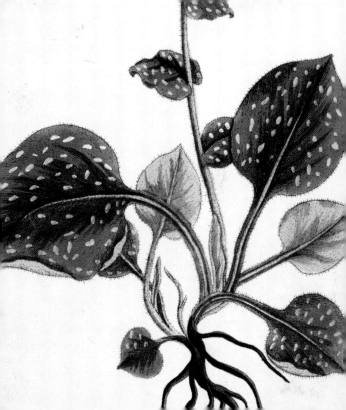

Stinging Nettle · *Urtica dioica*

[*Urtica*]

This Nettle grows to be two Foot high; the Leaves are of a lighter Green than the Roman Nettle; the Flowers are a dull Yellow.

The Nettle grows every where in too great Plenty, and flowers for several Months in the Summer.

The Roots, Leaves and Seed are used as cooling and restringent; the Juice is thought good for all kinds of inward Bleedings, Haemorrhagies and Fluxes. A Tent dipt in it stops the Bleeding of the Nose or Wounds. The Root is esteemed diuretic, and a Specific for the Jaundice. The Seed is recommended for Coughs, shortness of Breath, and Obstructions of the Lungs.

Sweet Flag · *Acorus calamus*

[The True Acorus, *Acorus verus*]

The Stalks grow about two Foot high, the Leaves are a light grass Green, and the Juli a light greenish Brown.

It grows in Rivulets, particularly in Surry, Cheshire and Norwich, and Shoots forth its Catkins in July and August.

The Roots are esteem'd hot, dry, opening and attenuating, and good for Obstructions of the Liver and Spleen; they provoke Urine and the Menses, help the Colick, resist Putrefaction, are useful against pestilential Contagions, and corrupt noxious Air; and are outwardly used in Sweet Bags & Perfumes. They are an Ingredient in the Theriaca & Mithridate.

Sweet Violet · *Viola odorata*

[March Violet, *Viola martia*]

The Stalks of this Violet creep on the Ground; the Leaves are a dark Green, and the Flowers a blue Purple.

It grows wild in Hedges, and is cultivated likewise in Gardens; and flowers in March.

The Flowers are one of the four Cordial Flowers; & esteemed cooling, moistning, and laxative, good in Affections of the Breast and Lungs, helping Coughs and pleuretic Pains. The Syrup is given to Children to open and cool their Bodies. The Leaves are cooling and opening, and frequently put into Glisters, and Ointments against Inflammations.

The Seed is reckon'd good for the Stone and Gravel.

The Officinal Preparation is the Syrupus Violarum.

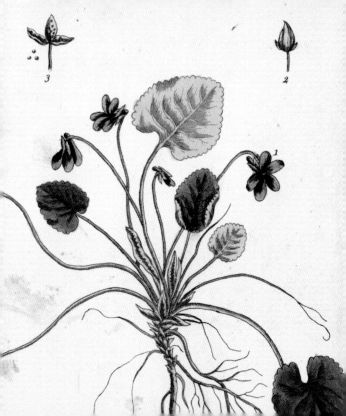

Sweet Woodruff · *Galium odoratum*

[Wood-roof, *Asperula odorata*, or *Aspergula*]

The Stalks grow to be a foot high, the Leaves are a deep grass Green, & the Flowers white.

It grows in Woods and Copses, and Flowers in May.

Wood-roof is esteemed a good Hepatic, and usefull against Inflammations of the Liver, Obstructions of the Gall Bladder, and Jaundice. The Germans put it into their Wine as we do Borrage & Burnet, as a great Cordial and Comforter of the Spirits. The Green Herb bruised is applied by the Country Folks to hot Tumours, Inflammations, and fresh Cuts.

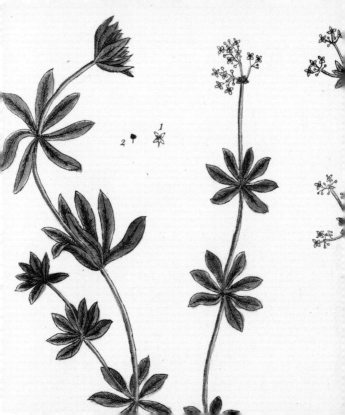

Tamarind · *Tamarindus indica*

[The East India Tamarind, *Tamarindus indica Orientalis*]

This Tree differs from the West India Tamarind in the Leaves & Fruit; & is better to be used in Medicines than the other because the Fruit contains more Pulp.

It grows in the East Indies and flowers in the Spring. This Specimen of the Tree and fruit is taken from the Malabar Garden.

Tamarinds are accounted cooling and opening, good to purge choleric Humors, and correct the bilious Heat of the Stomach and Bowels; they also are good to allay Thirst, promote Urine, and help the Jaundice.

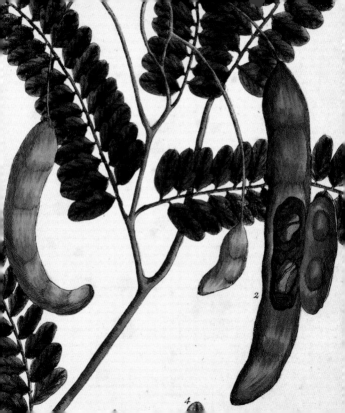

2

4

Tarragon · *Artemisia dracunculus*

[*Dracunculus hortensis*]

It grows to be two foot high, the Leaves are a shineing dark Green, and the Flowers a Yellowish colour.

It is planted in Gardens, and flowers in July and August.

The Leaves which are chiefly used are accounted heating and drying, good for those who have cold Stomachs, for which they are often put into Sallads; Some say they expell Wind, provoke Urine & the Menses.

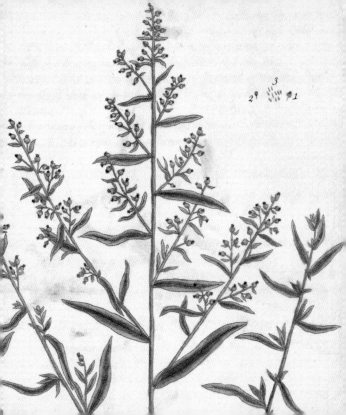

Thyme · *Thymus vulgaris*

[*Thymus*]

It grows about half a Foot high; the Leaves are a dark Green and the Flowers a pale Purple.

It grows wild in Spain, and flowers here in July.

Thyme is esteem'd heating and attenuating good to free the Lungs from viscid Flegm and help Wheesing and shortness of Breath. It is also accounted cephalic and good in all Diseases of the Head & Nerves. The Officinal Preparation is, The Oleum Thymi distillatum.

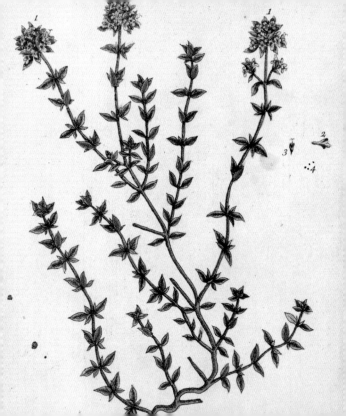

Tree Lungwort · *Lobaria pulmonaria*

[*Muscus Pulmonarius*]

This Moss has wrinkled tough Leaves, greenish above, & Ash-colour'd underneath.

It grows upon the Trunk of the Oak.

It is accounted good to stop inward Bleeding, & the too great Flux of the Menses. The common People use it for all Disorders of the Lungs & Breast, boiling it in Pectoral Drinks, & making Syrups of it. The German Ephemerides commend it as an extraordinary Remedy for the yellow Jaundice.

Turmeric · *Curcuma longa*

[Turmerick, *Curcuma*]

The Stalks of this grow about two Foot high, the Leaves are a bright Green and the Flowers red. This Specimen I had from the Leyden Garden, and the Roots from Mr. Nicholls.

It grows in the East Indies and flowers in June.

Turmerick is accounted attenuating, apperative & warming, good to open Obstructions of the Viscera, help the Jaundice, provoke Urine & the Catamenia; and is useful in a Cachexia, and good to accelerate the Birth.

2

2

Valerian · *Valeriana officinalis*

[*Valeriana* or *Phu*]

The Stalks grow three Foot high, the Leaves are a grass Green, and the Flowers white.

It is a Native of Italy, and is planted here in Gardens flowring in May.

The Root is esteem'd alexipharmic, sudorific & Cephalic, being of great Service in malignant Fevers & pestilential Distempers. It also helps the Head & Nerves, provokes Urine and brings down the Menses. It is an Ingredient in the Theriaca, and Mithridate.

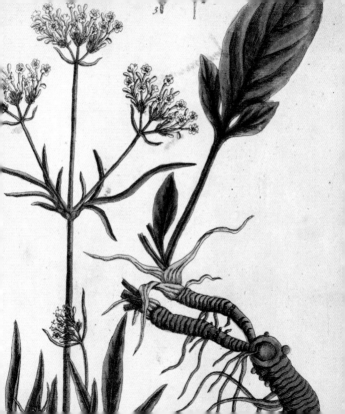

Verbena · *Verbena officinalis*

[Vervein, *Verbena* & *Verbenaca*]

It grows to be two Foot high, the Stalks are a purplish Brown, the Leaves a willow Green, and the Flowers pale Purple.

It grows in Highways, near Towns & Villages, flowring in July.

The Whole Herb is used, being accounted cephalic, good against Diseases arising from Cold and phlegmatic Causes. Some commend it to open Obstructions of the Liver and Spleen, help the Jaundice and Gout. Outwardly it is esteem'd vulnerary, good for sore watery inflamed Eyes.

Vervain Mallow · *Malva alcea*

[*Alcea*]

The Stalks grow about two Foot high, the Leaves are a grass Green, and the Flowers a pale Red.

It grows in Hedges, & flowers the greatest part of the Summer.

This Mallow is said to have the same Vertues as the common [see p. 164]. Dioscorides commends a Decoction of the Root in Wine, or Water; for those who are bursten, and for the bloody Flux.

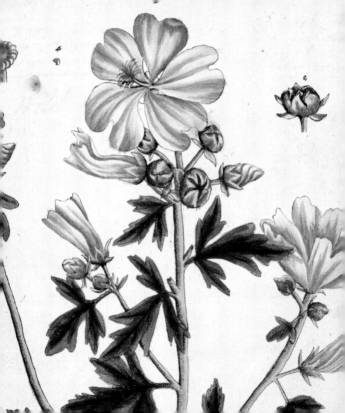

Viper's Bugloss · *Echium vulgare*

[*Echium*]

The Stalks grow about a Foot high, the Leaves are a deep grass Green, and the Flowers a blue Purple, with red Stamina.

It grows in Meadows, and flowers in July.

The Leaves and Flowers are used, and accounted good for the Bites of Vipers and other Venemous Creatures.

White Dead Nettle · *Lamium album*

[White-Archangel or Dead-Nettle,
Lamium album or *Urtica mortua*]

The Stalks grow to be a Foot high; the Leaves are a dark Green and the Flowers White.

It grows by Hedges, and flowers in April and May.

The Flowers are accounted a Specific against the Fluor albus, and are frequently made use of in a Conserve or Decoction for that purpose, which is to be continued for some time. Some recommend this Plant as of Great use against the King's-Evil, and all scrophulous Swellings. The officinal Preparation is, the Conserve of the Flowers.

White Horehound
Marrubium vulgare
[*Marrubium album*]

The Stalks grow about a Foot high, the Leaves are a light Green, and the Flowers white.

It grows by Road-sides and in Lanes, and flowers in June.

The Leaves and Tops are accounted hot, dry, and pectoral, and good to free the Lungs from tough viscid Phlegm, especially in cold moist Constitutions, the Juice being made into a Syrup with Sugar or Honey. They also open Obstructions of the Liver & Spleen, and are very serviceable against the Dropsy, Jaundice, Green Sickness, Obstructions of the Catamenia, suppression of the Lochia, & other Distempers of the female Sex; for which few Herbs go beyond it. The Officinal Preparation is the Syrupus de Prassio.

White Opium Poppy
Papaver somniferum
[White Poppy, *Papaver album*]

The Stalks grow about six Foot high, the Leaves are a pale Green, and the Flowers white.

It is sown in Fields and Gardens, and flowers in June.

From the Heads of these Poppies, (in Turky) the Opium of our Shops is produced; by making Incisions into them, the milky Juice which comes from the Wounds, is soon thick'ned by the Heat of the Sun, and then gathered and made up into Lumps. Opium is the greatest Anodine we have, easing Pain, procuring Sleep, stopping all violent Evacuations; and is an excellent Medicine in the Hands of a Wise Man; and ought never to be prescribed by any other; many fatal Accidents ensuing from the immoderate or unseasonable Use of it.

The Syrupus e Meconio or Diacodium is made of the Poppy Heads dried, infused & boiled in Water. The Seeds are much used in Emulsions being cooling and good in Fevers, inflammatory Distempers, the Strangury and Heat of Urine.

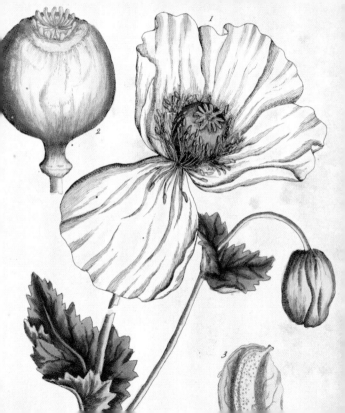

Wild Celery · *Apium graveolens*

[Smallage, *Apium*]

The Stalks grow to be two or three Foot high, the Leaves are a bright grass Green, and the Flowers yellow.

It grows in Marshy Places, flowring in June & July.

The Root is one of the five opening Roots, used in the Shops; and is accounted diuretic, and good for the stoppage of Urine, the Stone, the Gravel, Obstructions of the Liver & Spleen, the Dropsy, the Jaundice, & Obstructions of the Menses. The Leaves have much the same Qualities, and are eaten in the Spring to sweeten and purify the Blood, & help the Scurvy. The Seed is one of the four lesser hot Seeds used in the Shops; & is esteem'd carminative.

Wild Chicory · *Cichorium intybus*

[Wild Succory, *Cichorium sylvestre*]

The Stalks of this don't grow so tall as the Garden, but are more stubbed & twisted; the Leaves are a fine grass Green, and the Flowers a fine Blue.

It grows in Lanes and by Hedges, flowring in July and August.

The Vertues of this are much the same as the Garden [see p. 206].

Wild Strawberry · *Fragaria vesca*

[Strawberries, *Fragaria*]

This Plant creeps upon the Ground, the Stalks on which the Fruit grows are about Eight Inches long; the Leaves are a dark Grass Green, and the Flowers white.

They grow in woods, and flower in May, and the Fruit is ripe in June.

The Leaves are used in Lotions and Gargarisms for sore Mouths and Throats and Ulcers in the Gums. Some Authors commend them for the Jaundice and all kind of Fluxes.

The Fruit is accounted Cordial and good for hot bilous Constitutions, and grateful to the Stomach especially eaten with Wine and Sugar. The flowers make the Aq. Antinephritica. Caspar Comēlin.

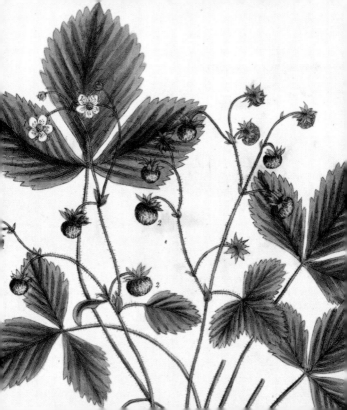

Willow · *Salix*

The officinal Willow is the largest of the Common Willows, & has long Narrow Leaves, green above and whitish underneath.

It grows commonly in moist Places, & bears Catkins in April.

The Juli, Leaves and Bark are said to be cooling and binding, & good for all kinds of Fluxes and Haemorrhagies. The Sap that comes from the wounded Bark is accounted good for inflam'd & bloodshot Eyes.

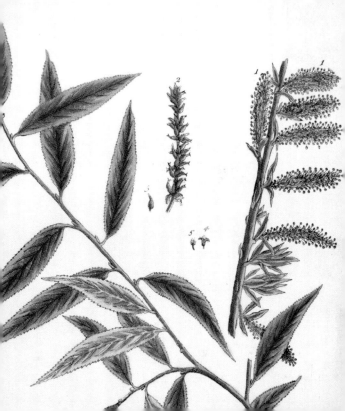

Yarrow · *Achillea millefolium*

[Yarrow or Milfoil, *Millefolium*]

The Stalks grow about eighteen Inches high, and are somewhat hairy; the Flowers are white, and grow on the Tops of the Branches in flat Umbels.

It grows in most Fields, and flowers in June and July.

The Leaves are esteemed cooling, drying, binding, serviceable in all kinds of Haemorrhages; as spitting or vomiting Blood, bleeding at the Nose, Dysentery, the too great Flux of the Menses, violent flooding, cooling and tempering its immoderate Sharpness; it is good in a Gonorrhea, Strangury, Heat of Urine; when applied outwardly it is of Service against Ruptures & staunches the bleeding of Fresh Wounds.

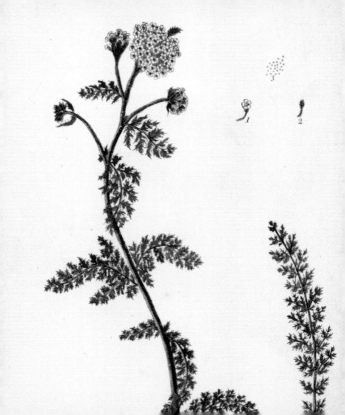

Yellow Asphodel · *Asphodeline lutea*

[Yellow Asphodel or King's Spear,
Asphodelus verus luteus or *Hasta Regia*]

The Stalks grow about two Foot high; the Leaves are a dark blue Green striped with a willow Green, and the Flowers yellow.

It grows naturaly in Italy and Sicily, and is planted here in Gardens flowring in April and May.

Dioscorides commends the Roots as good to provoke Urine and bring down the Menses; and an Ointment made from the Ashes of the Root he says procures the Hair to grow when it has fallen off thro' any Distemper.

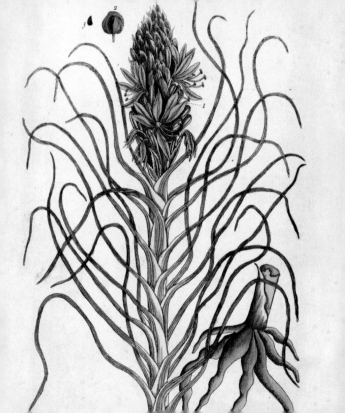

GLOSSARY

This glossary contains a selection of terms from Elizabeth Blackwell's herbal. Since the author's spelling of a word varies throughout the text, the contemporary rendering is listed. If a term is known by another word today, it is included in parentheses.

ALEXIPHARMIC: a cure for poison or infection.

ANODYNE: a means of providing comfort.

APERITIVE: a laxative, or a stimulant for the appetite.

APOZEM: a decoction made for pharmaceutical purposes.

CACHEXIA: weakness and wasting of the body due to chronic illness.

CANDY: an ancient name for Crete.

CARMINATIVE: expelling gas from the intestines or stomach to relieve abdominal pain.

CATAMENIA: the menstrual flow.

CATAPLASM (poultice): a soft and often heated, medicated mass, applied to a cloth and used on sores.

CEPHALIC: relating to the head.

DECOCTION: an extract produced by boiling plant material.

DEFLUXION: flowing down of fluids; inflammation or hair loss.

DETERSIVE: a cleansing material; a detergent.

DIURETIC: increasing the excretion of urine.

DROPSY (edema): swelling caused by excess fluids in the body's tissues.

EMOLLIENT: softening.

ERRHINE (sternutatory): a means of causing sneezing, crying, and vomiting.

FLUOR ALBUS (leukorrhea): a thick, usually white, vaginal discharge.

FOMENTATION: the use of hot and moist substances on the body.

GARGARISM: the liquid employed for gargling.

GLISTER (enema): the injection of fluid, by way of the rectum, into the lower bowel.

GRAVEL: a mass of small mineral salts in the kidneys and urinary bladder.

GREEN SICKNESS (chlorosis): hypochromic anemia.

HEPATIC: associated with the liver; often draining the liver.

HUMOURS: four fluids in the body that include phlegm, yellow bile, black bile, and blood.

IMPOSTHUME (abscess): inflamed tissue surrounding pus.

INCRASSATE: to thicken a liquid by the addition of another substance or evaporation.

JAUNDICE: the deposition of bile pigments that causes a yellow-tinted pigmentation in the skin, tissues, and body fluids.

KING'S EVIL (scrofula): tuberculosis of lymph nodes, often in the neck.

LIXIVIUM: an alkaline solution extracted by leaching wood ashes.

LOCHIA: the discharge, following a delivery, from the uterus and vagina.

MENSES: the menstrual flow.

PHYSICK (physic): the practice of healing.

PILES: synonym for hemorrhoids.

REINS: kidneys.

RHEUM: a liquid discharge from the mucous membranes of the nose or eyes.

SECUNDINES (afterbirth): the expelled placenta and fetal membranes following delivery.

SEMICUPIA: a hip bath.

SEROUS: transparent or yellowish bodily fluids.

SOUPLING: softening or comforting.

STIPTIC (styptic): halting bleeding.

STONE: hard matter causing intense pain in some of the body's organs.

STRANGURY: a slow-moving, spasmodic discharge of urine.

STUPE: a warm, medicated cloth externally applied.

SUDORIFIC: inducing sweat.

SWEET BAG (sachet): a small, often decorative bag used to carry perfumed sachet or other small items.

TETTER: a vesicular skin disease, such as eczema or ringworm.

THRUM: a fiber, hair, or slender leaf found on a plant.

TISSICK (tuberculosis): bacteria that usually attacks the lungs.

VENICE TREACLE or *Theriaca andromaci*: a pharmaceutical preparation dating from at least the second century BCE, and widely prescribed through the mid-eighteenth century. It contained, among many other ingredients, viper flesh and opium.

VULNERARY: helpful for healing wounds.